IMAGES
of America

# SUNNYVALE

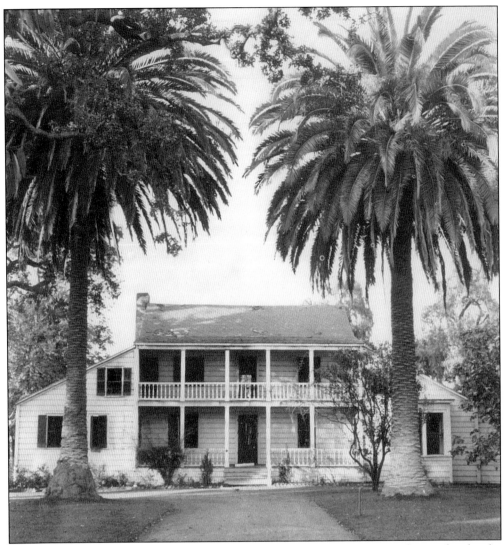

**BAY VIEW.** Martin Murphy Jr. erected this two-story residence in 1850 and named it for the spectacular vista of the southern tip of the San Francisco Bay that could be enjoyed from its front porch. It was the first framed house in the valley and was constructed with wooden pegs because iron nails were not available. It served as the Murphy family residence for over a century. (Courtesy Sunnyvale Historical Society.)

**ON THE COVER:** The Sunnyvale Volunteer Fire Department poses with a newly purchased Seagrave pumper truck (on the right) in 1925 in front of the Washington Avenue firehouse. Among the volunteers are Antone (Tony) Vargas (fourth from left), brother of "Mr. Sunnyvale" Manuel Vargas; electrician H. G. Wanderer (eighth from left); and livery man Bill Wetterstrom (third from right). (Courtesy Sunnyvale Historical Society.)

IMAGES
*of America*

# SUNNYVALE

Ben Koning and Anneke Metz
with the Sunnyvale Historical Society
Foreword by Michael S. Malone

ARCADIA
PUBLISHING

Published by Arcadia Publishing
Charleston, South Carolina

Printed in the United States of America

Library of Congress Control Number: 2010936334

For all general information, please contact Arcadia Publishing:
Telephone 843-853-2070
Fax 843-853-0044
E-mail sales@arcadiapublishing.com
For customer service and orders:
Toll-Free 1-888-313-2665

Visit us on the Internet at www.arcadiapublishing.com

*This book is dedicated to the many men and women
of the Sunnyvale Historical Society who have tirelessly
preserved local history for generations.*

# CONTENTS

# FOREWORD

Though its impossibly cheery and optimistic name has been a source of humor for more than a century, no city has ever been more appropriately named than Sunnyvale, California. When real estate speculator Walter Crossman, hoping to entice more customers, decided to attach this upbeat moniker to his new housing development in the old Encinal, he had little idea how prescient he was.

Look at the cover of this book. Taken in 1925, it is ostensibly a standard Edwardian guild photograph, in this case of a group of firemen. But note the odd juxtaposition of those two signs. There is the present ("Passing Quickly"), apparently equated to the aging water pumper, no doubt about to be abandoned, behind the sober, crouching men. And lurking in the corner, as it always has in Sunnyvale's history, behind the cutting edge technology of the shiny new ladder truck, is the future. Its appended question mark poses the unsaid, but perpetual, challenge: if you can seize it!

And Sunnyvale always has.

Crossman meant for the new name to attract winter-weary Easterners to a new world of (to use the name of local book of the era) "Sunshine, Fruit and Flowers." And as the old photographs in this book attest, that wasn't a bad description of Sunnyvale at the beginning of the 20th century. But Crossman equally captured the other "sunniness" that would come to characterize this community—that endless, indomitable optimism that would drive the entrepreneurial spirit of Sunnyvale, and the men and women imbued with that spirit, to invent the digital age and modern world.

That spirit has always defined Sunnyvale. It was there with Martin Murphy and his family during one of the epic pioneer journeys in American history. And it was there among the men and women who turned Santa Clara Valley into the agricultural heartland of the Pacific; at Hendy Iron Works, building the US Navy; at Echophone, Silicon Valley's first tech start-up; at Lockheed and NASA-Ames, in the cockpit of the Space Age; and most famously, with Steve Jobs and Steve Wozniak of Apple Computer, Nolan Bushnell of Atari, and Ted Hoff of Intel—inventing, respectively, the personal computer, the computer game, and the microprocessor, three cornerstones of our new global economy.

Only when the future is perpetually perceived as better than the present, and only when you have the optimism, the talent, and the courage to seize that future, can you accomplish historic change. And the people of Sunnyvale have done just that. They took a community of housing developments and orchards named for a marketing campaign and made it the Heart of Silicon Valley—and thus of the electronics age, the new world of silicon, software, and cell phones. Look past the old-fashioned clothes and buildings in these extraordinary photographs and instead study the tough, ambitious, yet kind faces of nearly two centuries of Sunnyvale citizens. Through their contributions, both small and great, they gave us our world.

—Michael S. Malone

# ACKNOWLEDGMENTS

In 2005, I was asked to film Ann Zarko for the Sunnyvale Historical Society. Ann had lived in the area for 95-plus years, and her razor-sharp memory took me straight to 1931. Imagine running home through dusty orchards at sunset, anticipating a ride in the family Model T—with a driver's license issued at the local gas station!

While completing the film, I enjoyed unlimited access to the society's collections while their new $2.5-million museum, the product of 40 years of hope and hard work, rose between the apricot trees of Orchard Heritage Park. I learned then, to my surprise, that a Sunnyvale title was absent from Arcadia Publishing's Images of America series. With the museum complete, it was time to fix this omission.

I am grateful to Johan and Elisabeth Koning for their bottomless support and love, Jeanine Stanek and Chiyo Winters for their tireless research, and Mary Jo Ignoffo, whose publications are the first and last word regarding the history of Sunnyvale. Above all, I wish to thank Anneke Metz for providing the energy, resolve, and great writing that turned good intentions and procrastination into the reality of this book.

—Ben Koning

Sunnyvale became my hometown when I was nine. I remember with fondness biking its quiet, wide residential streets in the 1970s and catching movies at the Hacienda theaters on El Camino Real. I learned the names of the states on the huge painted map at Panama School before it was bulldozed, and I am a proud 1985 graduate of Fremont High. I loved my first job at the Longhorn Steakhouse—so busy sometimes I could have sworn the whole town was there!

I have lived in many places since then, but Sunnyvale is still in my blood. I thank Ben Koning for the incredible legwork, writing, and photograph gathering that made this book a reality, and I also thank the volunteers of the Sunnyvale Historical Society. This book would not have been possible without their tireless efforts to preserve the history of this place that, in my heart, is still my home.

—Anneke Metz

Unless otherwise noted, all images appear courtesy of the Sunnyvale Historical Society. Other sources are abbreviated as follows:

| | |
|---|---|
| (CHC) | California History Center, De Anza College |
| (MV) | Mountain View History Center, Mountain View Public Library |
| (NDNU) | California Provincial Archives, Sisters of Notre Dame de Namur |

# INTRODUCTION

Sunnyvale, known as "the Heart of the Silicon Valley," might just as easily be called "the Little City That Could." With a population of 130,000, it is small by world standards, but it has made enormous contributions to national and international industry. For thousands of years, it was home to the indigenous Ohlone people. The Spanish established missions in the area in the 1770s, but the town's modern era began in 1850, when Irish immigrant Martin Murphy Jr. and his family established the Bay View ranch.

From the very beginning, Murphy set a tone of entrepreneurship and innovation. Murphy allowed the San Jose and San Francisco Railroad Company to build a railroad line across his lands to San Francisco. That track became the first completed railroad line in the state in 1864, and Murphy's foresight fueled the growth of the region. Wheat and then fruit agriculture were the valley's first economic mainstays, but technological innovation began early in Sunnyvale.

Orchards dominated the landscape until about 1950, but while fruit was king, equipment manufacturing was gaining steam. The Joshua Hendy Iron Works and other heavy manufacturing concerns moved to town after the 1906 San Francisco earthquake. Wooldridge, manufacturer of road graders, and Johnson Tractor were there, too.

Many industrial factory towns have withered away as times have changed, but Sunnyvale has always been a trendsetter, bringing new opportunities to the valley and keeping the area vibrant. After World War II, Hendy was sold to Westinghouse, and it later became part of Northrop Grumman; it still produces military and industrial equipment, as it has for over 100 years. In the 1930s, Sunnyvale campaigned for a new naval base: Naval Air Station Sunnyvale. It became Moffett Field, for years the home of the Pacific air patrol fleet. NASA's Ames Research Center is still there. Lockheed came after World War II, and the defense contractor became Sunnyvale's major Cold War employer.

Sunnyvale's rich history includes many early electronic innovators. Albert W. Bessey, founder of the Jubilee Incubator Company, patented safer chicken brooders in the 1920s. His son was radio pioneer Arthur E. Bessey, who built some of the world's first home radio consoles. In the 1970s, Sunnyvale became ground zero for the home computer revolution. Legendary Apple founder Stephen Wozniak grew up in Sunnyvale, and Atari started here in 1972.

Sunnyvale is largely suburban now, so it is perhaps not surprising that tiny "Murphy's Station" also attracted real estate entrepreneurs from the very beginning. Walter E. Crossman started a large housing tract in what is now the Historic District around 1900. Notable architects have left their mark as well, including Joseph Eichler, whose "California modern" homes influenced much of Sunnyvale's postwar suburban expansion.

A leader in industry, Sunnyvale has also led by example in civic affairs. It was the first city in California to have a female mayor and one of the first to form an integrated public safety department. Perhaps it is appropriate that Sunnyvale is a quiet town: its long list of accomplishments speaks for itself, and Sunnyvaleans can take pride in the rich heritage of innovation that has shaped it into a truly world-class city.

# One

# Murphy and Other Pioneers

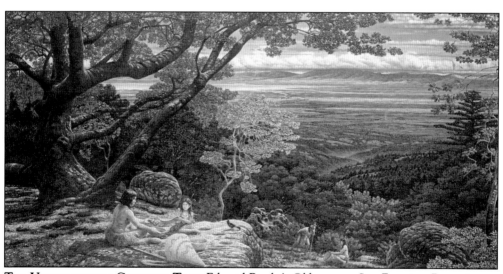

**The Valley during Geologic Time.** Edward Rooks's *Ohlone over San Francisco Bay* painting re-creates a prehistoric view of the Santa Clara Valley floor as it would be seen from today's Castle Rock State Park looking northeast over Saratoga Creek. The valley was covered with great oak trees until waves of settlers retooled the landscape into ranches, wheat fields, orchards, and finally suburbs, all in less than 200 years.

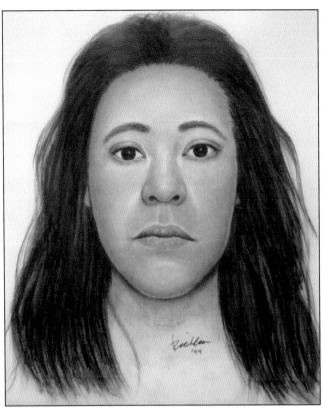

**OHLONE WOMAN, 771 AD.** The area's original inhabitants were the Ohlone people: hunter-gatherers who lived in small villages. Karen Oeh (Cal State Chico) and the San Jose police forensic unit reconstructed this likeness of a young Ohlone woman from a skull found during construction in 1995 at the Mission Santa Clara. The remains were reburied in a ceremony including elders from the Muwekma Ohlone tribe.

**SUNNYVALE AS PASTORAL LANDSCAPE.** Spanish missionaries arrived in the late 1700s. The land became Mexican territory, and Francisco and Inez Estrada were granted the 9,000-acre Rancho Pastoria de las Borregas (Pasture of the Lambs) in 1842. The land later passed from Francisco's father, Jose Estrada, to Inez's father, Mariano Castro. Martin Murphy Jr., at the time also a Mexican citizen, purchased 4,900 acres from Castro for $12,500 in 1850.

**MARTIN MURPHY JR. AND HIS WIFE, MARY.** Martin Murphy Jr. emigrated from Wexford, Ireland, in 1828. Mary Bulger had emigrated separately as a 12-year-old girl in 1820. Martin and Mary knew each other as children, as they had lived on adjoining farms. After reuniting in Quebec, Canada, they married in 1831 and blazed the trail to California in 1844. Martin and Mary had a total of 11 children, but daughters Mary, Nellie, and Eliza all died of cholera at young ages. Sons James, Martin III, Patrick, and Bernard made the journey with their parents to California; during the trek, Elizabeth (Yuba) was born. James T. (named after his older brother, who died the day he was born), Mary Ann (Polly), and another Nellie were born in California. Murphy ranched in the Sacramento area until 1850, when he purchased the Pastoria. The Murphys celebrated their 50th anniversary in 1881, at what was easily the most lavish party that the region had ever seen. Everyone in the valley came—perhaps 5,000 people.

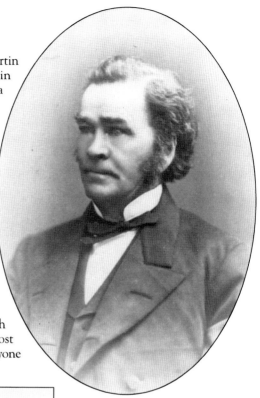

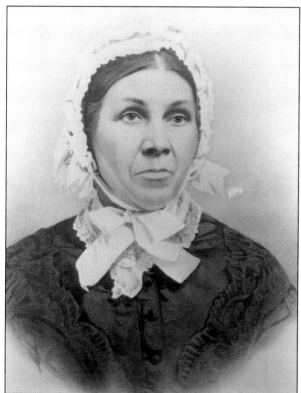

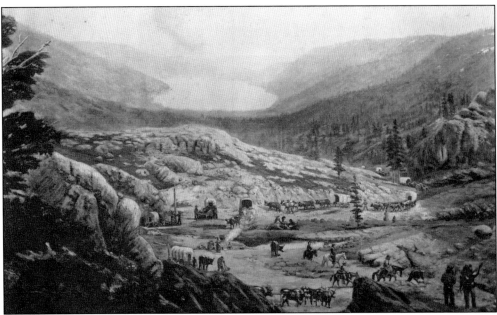

**Murphy-Townsend-Stephens Wagon Train at Truckee (later Donner) Lake, October 1844.** Led by Elisha Stephens, the Murphy wagon train was the first to use what is now known as the Donner Pass. Although some of the party ended up snowbound near the Yuba River, all were rescued by March 1845, and no lives were lost. Two years later, the Donner Party was not as lucky. (Painting by Andrew Hill.)

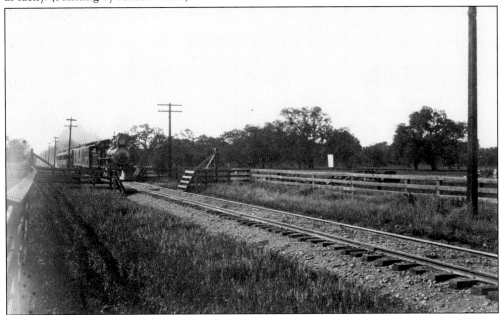

**The Journey Begins.** Murphy settled in the south bay, built Bay View ranch, and planted wheat, but he quickly recognized that the area needed reliable transportation. On July 27, 1861, he deeded the right of way for the San Francisco and San Jose Railroad Company to construct a railroad through "the lands belonging to me." The 50-mile rail line, completed in January 1864 and shown here around 1920, was the first working railroad in the state.

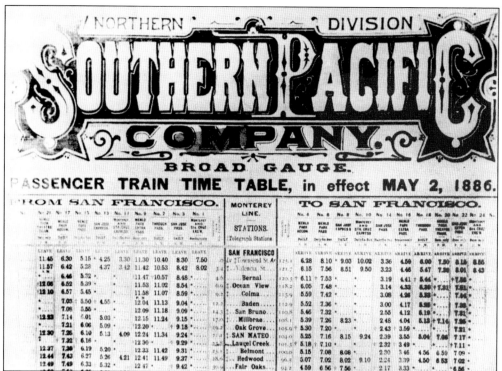

**SOUTHERN PACIFIC RAILROAD TIMETABLE.** By 1870, Southern Pacific was operating freight and passenger service on the San Francisco–to–San Jose line. This 1886 schedule shows trains stopping at Murphy's Station along the way. A one-way trip from Murphy's Station up to San Francisco took less than 90 minutes. By comparison, the stagecoach could take up to nine hours on muddy, rutted dirt roads and cost $32 (in 1901 dollars).

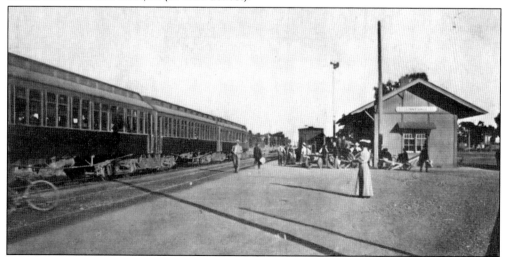

**RAILROAD DEPOT AROUND 1920.** By 1920, Southern Pacific had been ferrying passengers up and down the peninsula for half a century. The rail line continued passenger service through Sunnyvale until 1980, when passenger service was transferred to Caltrans, which branded it as Caltrain in 1987. Sunnyvale citizens still commute to San Francisco by train as they have for nearly 150 years.

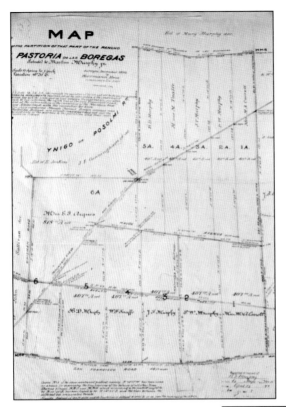

**LANDS DIVIDED, 1893.** Martin Murphy Jr. died in 1884 and Mary in 1892. Their estate, reaching from the bay down to Old San Francisco Road (Reed Avenue) and bounded by Whisman Road to the west and today's Wolfe Road/Fair Oaks Avenue to the east, was divided into 820-acre parcels for the five surviving children and the late Elizabeth Yuba's grandchildren. These lands form the core of the city today.

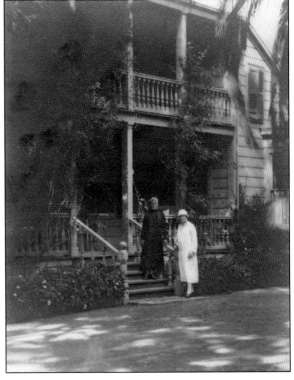

**BAY VIEW AROUND 1920.** A daughter of Martin Murphy Jr., Mary Ann "Polly" Murphy (left), married Richard Carroll and had three children: John, Elizabeth, and Gertrude. After Richard's death in 1890, Polly had to sell parts of her property to make ends meet. Her daughter Elizabeth Whittier (in white) took over the Murphy family home in 1917 and lived there until a few years before her death in 1954.

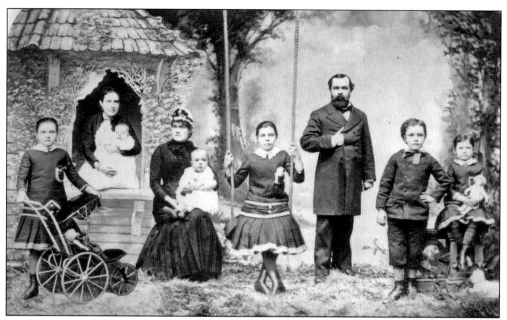

**Bernard "B.D." Murphy Family around 1880.** Mary and Martin Murphy's son Bernard "B.D." became mayor of San Jose and a California state senator; he had nine children. From left to right are daughter Evelyn Ann, Annie Lucy (B.D.'s wife, with son Patrick), "Aunt Polly" (B.D.'s sister Mary Ann), her daughter Elizabeth, B.D.'s daughter Mary, B.D., his son Martin IV, and his daughter Elizabeth. (NDNU.)

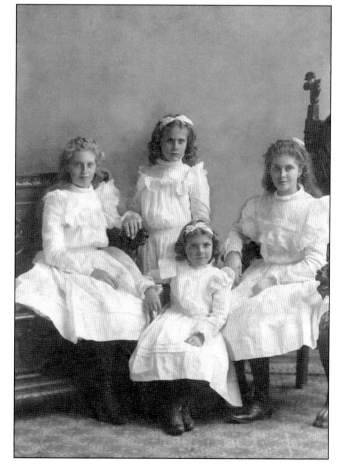

**Great-Grandchildren around 1900.** These four sisters (from left to right: Mary Ann, Elena, Martina, and Rose) were great-granddaughters of Mary and Martin Murphy Jr. and granddaughters of Elizabeth Yuba Murphy via her son Martin J. Taaffe and his wife, Rose Marie Hoffman. Sunnyvale's Taaffe Street, which runs through the heart of downtown, is named after the family.

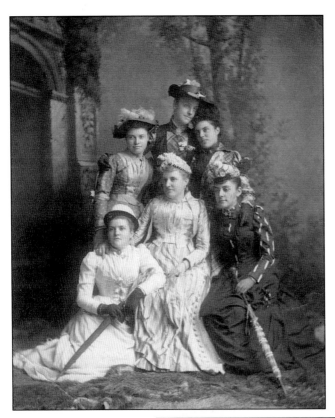

**MURPHY FAMILY COUSINS AROUND 1895.** The extended Murphy clan stayed closely knit, as shown in this portrait of five of Martin Murphy Jr.'s grandchildren. Surrounding B.D. Murphy's wife, Annie Lucy (née McGeoghenan), are (clockwise from top) Maud Arques (daughter of B.D.'s sister Nellie and namesake of Arques Avenue), Elizabeth Carroll (daughter of B.D.'s sister Polly), Gertrude Murphy and Helena Murphy (B.D. and Annie's daughters), and Wilhelmina Murphy (daughter of B.D.'s younger brother James).

**VIRGINIA REED MURPHY AROUND 1915.** Only 13 when she survived as a member of the Donner Party of 1846–1847, Virginia Reed grew up to become a member of the Murphy family. She eloped with Martin Murphy Jr.'s brother John, had nine children, and lived until 1921. She is photographed here in Capitola with her great-grandniece Evelyn Derby, granddaughter of Gertrude Carroll and great-great-granddaughter of Martin Murphy Jr.

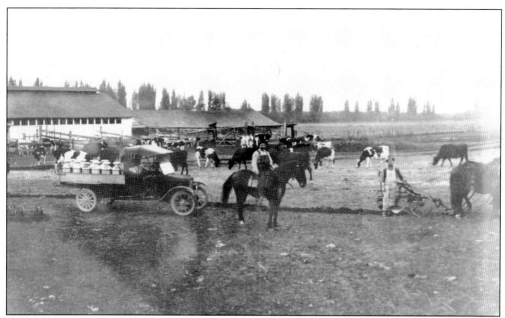

HOLTHOUSE FARM AROUND 1910. With the train running through Murphy's Station, the region attracted other farmers and ranchers. Eberhardt Henry Holthouse emigrated from Osnabrück, Germany, in 1849 and settled on this 147-acre farm in 1874. Holthouse grew acres of wheat, planted and harvested by laborers using teams of horses. The Holthouse farm also had dairy cattle (above and below); 20 acres of apple, pear, plum, and peach trees; and 7 acres of strawberries. The farm was later owned by Holthouse's sons. Located directly adjacent to the parcel of land that became Naval Air Station Sunnyvale in 1931, part of the property was sold to the US government in the 1950s to expand the runways at what was by then called Moffett Field. Much of the rest of the original farm is now the Lockheed Martin campus.

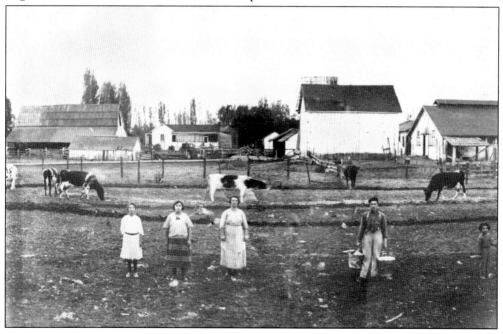

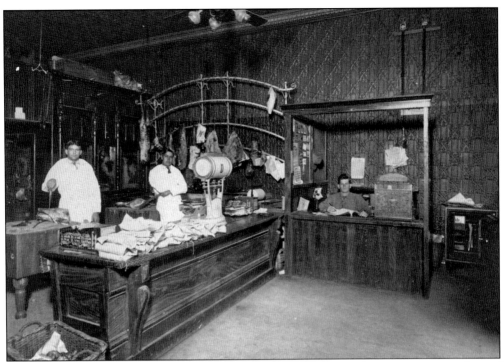

**TRUBSCHENCK BUTCHERS AROUND 1918.** Several prominent Sunnyvale citizens were members of the Trubschenck family. William Trubschenck, son of Danish immigrant Herman, ran the first meat market in town in the 100 block of Murphy Avenue, expanding as local demand grew. Bill is shown on the far right at the cash register. William's sister Ida was Sunnyvale's first town clerk.

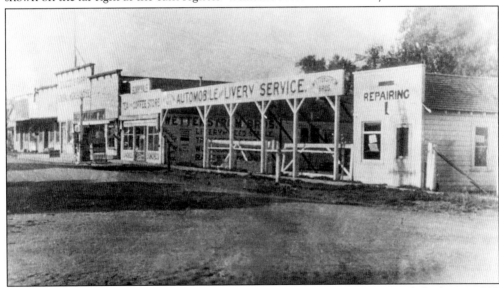

**EVELYN AVENUE NEAR TAAFFE STREET AROUND 1915.** By the 1910s, Sunnyvale had over 1,000 citizens and large, if unpaved, downtown streets. Downtown merchants on Evelyn Avenue included a general merchandise store, Sunnyvale Tea and Coffee (which also sold lunches), the Wetterstrom Brothers Livery, and a cobbler. As its horse boarding business waned, Wetterstrom's added automobile service.

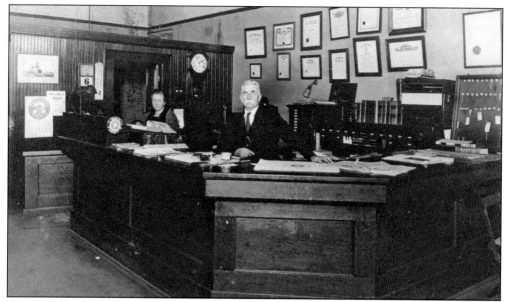

**CHARLES LINCOLN STOWELL, DEVELOPER AND ORCHARDIST, 1907.** The year before, Charlie, as he was known, had built the town's first large commercial building, the S&S Building, at the corner of Murphy and Washington Avenues with his brother-in-law, C.C. Spalding. Stowell went on to build Sunnyvale's first post office on Washington Avenue and also served as chairman of the committee to build Fremont High School.

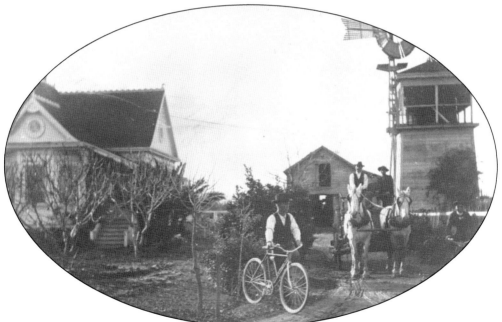

**STOWELL RANCH AROUND 1906.** Charles L. Stowell bought this home in 1898 and operated an orchard on the surrounding 25 acres. The Stowell farm was the longest continually operating farm in Sunnyvale. Its fruit stand stayed open until the death of Charles's daughter-in-law Dolly in 1999. The home, built in the Queen Anne style, still stands on Sunnyvale-Saratoga Road just north of Remington Drive.

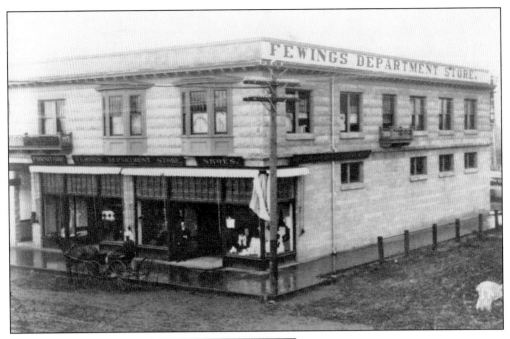

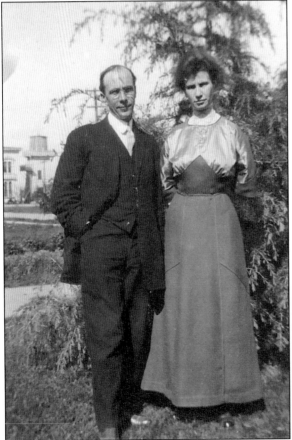

**FEWINGS DEPARTMENT STORE AROUND 1910.** The store, housed in the S&S Building, advertised "dry goods and notions." Fewings later became Kirkish Western Wear. Upstairs meeting halls were used by the Baptist congregation and other groups, such as the Sunnyvale Rebekahs. In the 1950s, the top floor was occupied by three physicians, including Dr. Howard Diesner. Today, the building anchors the revitalized 100 block of Murphy Avenue.

**FREDERICK AND MRS. FEWINGS, JUNE 1912.** Charles Fuller, realtor, Baptist preacher, and Sunnyvale postmaster from 1915 to 1932, was keenly interested in photography and documented scenes around the growing town in early 1900s. He took this photograph of the founders of Fewings Department Store. (CHC.)

**First Mail Carriers, 1929.** In the early days, all mail was delivered to the Sunnyvale post office (a tiny closet in F.E. Cornell's Country Emporium at the corner of Murphy and Evelyn Avenues) as general delivery. As the town grew, Bill Golick (left) and Willard Peterson were hired as the town's first mailmen. Each covered half of the town.

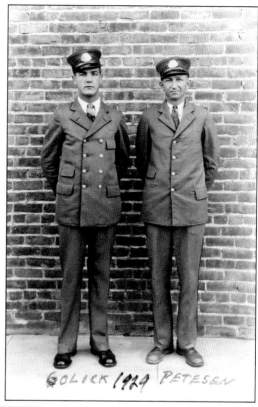

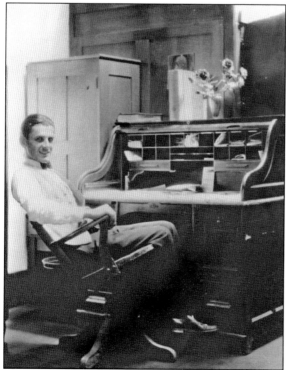

**Sunnyvale Postal Worker Joe Stanich, 1930.** Stanich started with the post office while still a young boy, running errands, raising the flag every morning, and tending the heating stove. He worked his way up to sorting mail and was a longtime assistant postmaster. He served as Sunnyvale's postmaster from 1957 to 1965.

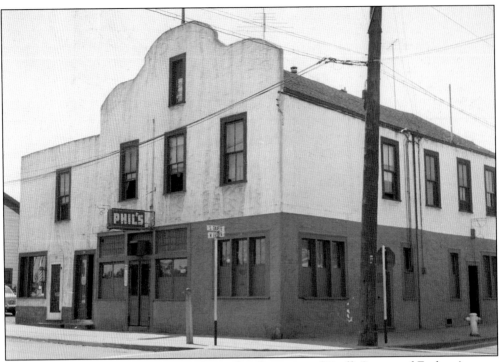

**First Newspaper.** This building, which stood at the corner of Taaffe Street and Evelyn Avenue, housed Sunnyvale's first newspaper, the *Standard*. It was published weekly from 1905 to 1970. For most of the early years, it was run by W.K. Roberts, who was also Sunnyvale's first justice of the peace. The building is shown here around 1950 as Phil's Bar. Today the corner is part of Sunnyvale's Plaza Del Sol.

**Bank of Italy Building, 1921.** In 1905, orchardist Charles Clifton Spalding (who also built the S&S Building with Charlie Stowell) used $25,000 to organize the Bank of Sunnyvale, serving as its first treasurer and later its president. It became the Bank of Italy in 1920. In 1921–1922, the bank built the imposing concrete branch office that stood for over 50 years on the corner of Washington and Murphy Avenues.

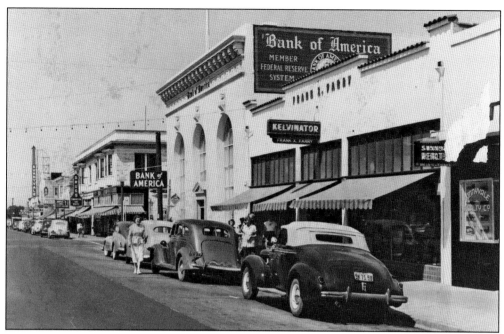

MURPHY AVENUE SHOPPING DISTRICT, JULY 1949. Murphy Avenue grew over the years and became Sunnyvale's center of commerce. The Bank of Italy building, by now the Bank of America, anchored the street. The S&S (Kirkish) Building and the Sunnyvale Cinema can be seen in the distance. The three buildings served a half-dozen or more roles each over the years.

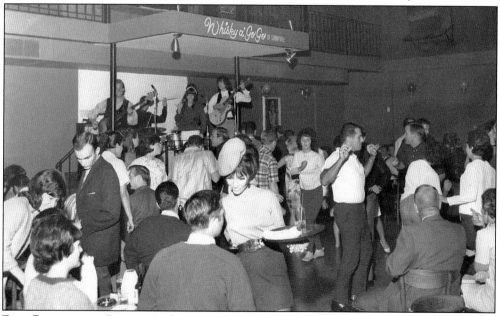

FROM PASSBOOKS TO PARTIES. In the 1960s, the Bank of Italy building fell on hard times. Bought by entrepreneur Joseph Lewis in 1965, the building briefly housed the Whisky a' Go Go of Sunnyvale club, shown above with the Joel Scott Hill Trio performing. Once the go-go dancing craze faded, Lewis remade the business as Wayne Manor, a nightclub with live entertainment and a campy Batman theme. (Courtesy Ross Hannan.)

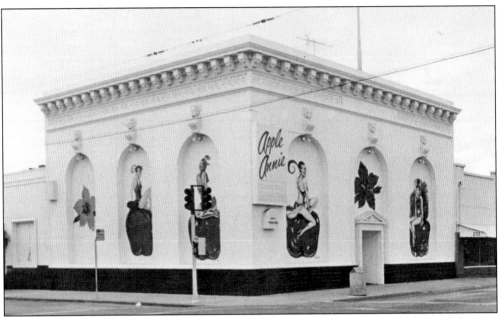

**BANK OF ITALY BUILDING DESTROYED.** The "Batcave," as Wayne Manor was affectionately known, didn't last either, and the building finally became Apple Annie's strip club (above). Gone were the high arched windows, replaced by paintings of burlesque ladies. Finally, in 1977, the building was destroyed (below) to make way for the Sunnyvale Town Center mall, a sad end for a once-grand structure.

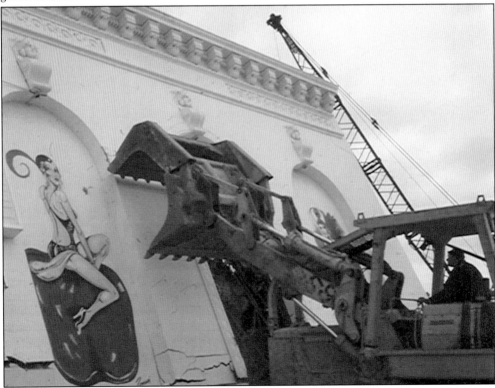

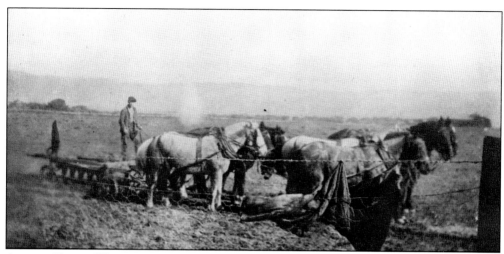

**ANTONE VARGAS WORKING IN THE FIELD AROUND 1890.** Antone Vargas emigrated from Portugal in 1880 and worked for Martin Murphy Jr. raising barley and wheat on the 200 acres that Martin's son Patrick would later sell to Walter E. Crossman. As payment, Vargas took a 25-percent cut of the crops, or one out of every four sacks of grain. Antone's son, Manuel, would become one of Sunnyvale's great champions.

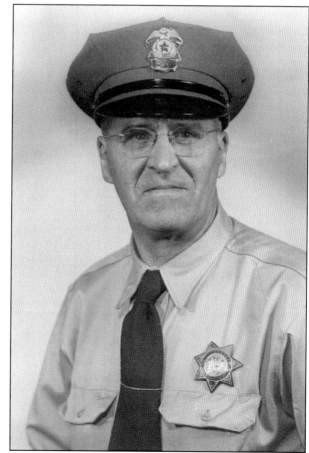

**MANUEL VARGAS (1893–1986).** Vargas served as Santa Clara County deputy sheriff for 40 years, but many knew him simply as "Mr. Sunnyvale." He worked tirelessly as an unofficial city historian. With Pat Malone, he began the Sunnyvale Historical Society's decades-long effort to rebuild Murphy House as a museum after its destruction in 1961. On his 87th birthday, the city declared October 20 Mr. Vargas Day in a surprise ceremony.

**GRANDFATHERED IN.** At the age of 7, Manuel Vargas planted these coast redwoods in 1900 on his 10-acre family farm at what is now the intersection of Mary and Carson Avenues. Although he illegally acquired the saplings during a family fishing trip, the trees were a protected historic site by the time he died as the oldest living resident of Sunnyvale. Manuel and his wife, Mary, were also at one time the longest-married couple in Santa Clara County. (Courtesy Johan Koning.)

**LOUIS STOCKLMEIR'S ORCHARD, 1980.** His trade was insurance, but Stocklmeir was most passionate about orchards and preserving local history. He cofounded the Cupertino Historical Society and De Anza College's California History Center. Stocklmeir died in 1982, but some of his orchards, including an orange grove, are preserved as the Legacy Farm on the banks of Stevens Creek. A Sunnyvale elementary school was named in his honor in the 1960s.

# *Two*

# FERTILE GROWTH

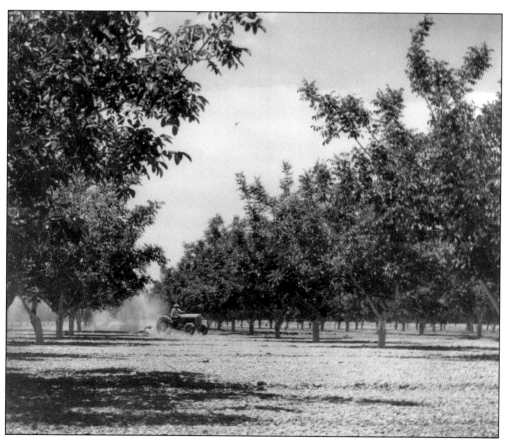

**TENDING AN ORCHARD IN EARLY SUNNYVALE.** After unfavorable tax laws and soil degradation had made wheat farming unprofitable by 1880, the valley's economy shifted to fruit production. Cherries, apricots, and prunes were the mainstays of the industry, and in its agricultural heyday of the 1920s and 1930s, the valley floor had 100,000 acres of orchards with perhaps 10 million trees.

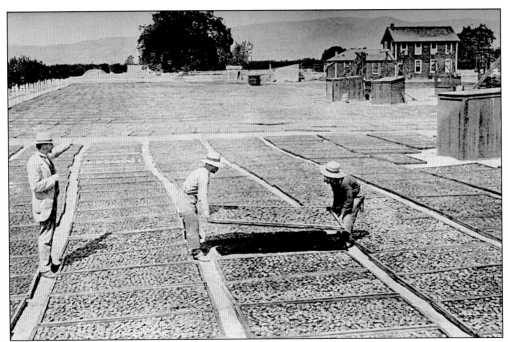

**APRICOTS DRYING, 1920S.** An early Sunnyvale postcard shows the preparation of sun-dried apricots. Ripe apricots were harvested, pitted, cut in half, treated with sulfur, and laid in the sun on three-by-eight-foot trays to dry. Apricots are still grown today in Sunnyvale at the city's Orchard Heritage Park and dried in this time-tested way.

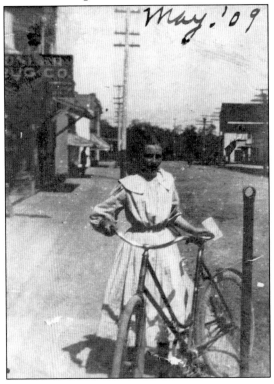

**DORIS ATKINSON (LATER LYNN), MAY 1909.** Taken the year she graduated from the Encina grammar school, this photograph shows Doris, age 14, on a second-hand bicycle earned by picking prunes in the Sunnyvale orchards. She recalled working "in the fruit" each summer with her friends starting in 1903, when she was just nine years old. She also worked canning peaches for Libby's when she was a bit older.

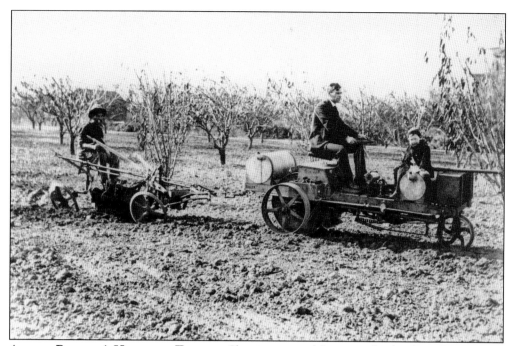

**ARTHUR BUTCHER'S HOMEMADE TRACTOR.** Showing some of the spirit of technological innovation for which Sunnyvale would become famous, Arthur Butcher (with his son Harold and an unidentified laborer riding along) drives a tractor of his own design. He built the rig after becoming frustrated with the horse-drawn kind on the family's land near Butcher's Corner (now a triangle-shaped intersection at El Camino Real, Fremont Avenue, and Wolfe Road) in 1911. (Courtesy Robert Butcher.)

**FARM WORK: MECHANIZED.** In response to a growing need, Fordson tractors were developed by Henry Ford and his son Edsel as the first mass-produced affordable tractor. A young Raymond Tikvica is shown around 1928 on an early Fordson. With a maximum speed of six miles per hour, no brakes, and a tendency to flip over backwards, the Tikvicas' Fordson was reportedly dangerous to operate. (Courtesy Raymond Tikvica.)

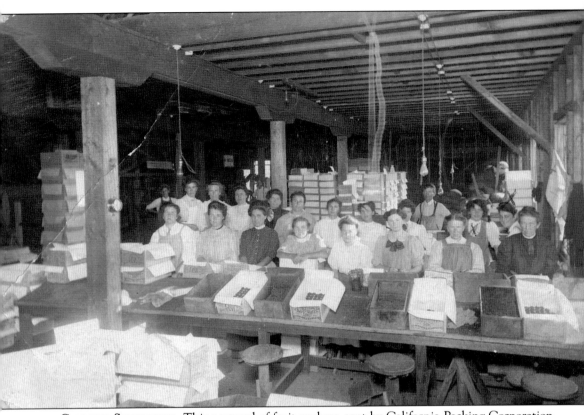

**CANNING SISTERHOOD.** This postcard of fruit packers, sent by California Packing Corporation (Calpak) worker Mabel Coates to her sister Helen in 1909, was taken inside one of the company's buildings. The entire facility was constructed of redwood, which is naturally rot- and insect-resistant and was said by workers to keep the mice and rats away.

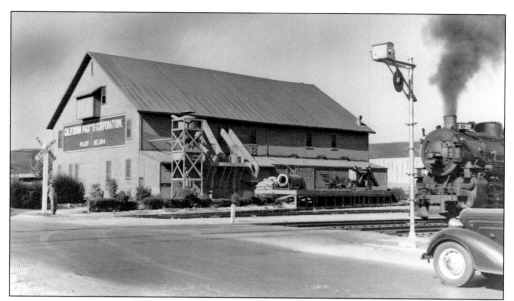

**CALIFORNIA PACKING CORPORATION (CALPAK) BUILDING, 1930.** Madison and Bonner fruit packing company started in 1904 on Evelyn Avenue, next to the railroad tracks. Changing its name to Calpak, the firm abandoned the building in 1926, but in 1930, championed by 22-year-old employee Hermann Horn, it became their Sunnyvale Seed Germination Laboratory. In 1967, Calpak changed its name to Del Monte.

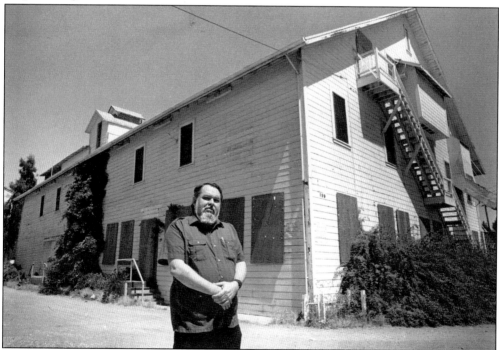

**ALMOST SAFE.** By 1989, the Del Monte building was owned by the Southern Pacific Railroad, and the building was destined to become a city parking lot. Happily, David B. Ogle (pictured) and other citizens rallied to save it. In 1993, it was named a city landmark, moved to 100 South Murphy Avenue, and refurbished. It is now a popular wedding spot. (Photograph by Steve Castillo.)

**SCHUCKL OPERATIONS.** At the cannery, fruit from nearby growers was moved into the plant via conveyer belt (above, shown around 1950), sorted, pitted, sliced, canned, and labeled. Giant boilers provided the steam needed for processing the fruit (below). Both men and women worked in the canneries; men operated the machinery, and women handled the fruit. The boilers shown were installed in 1927 and 1929. (Above, courtesy Kay Peterson.)

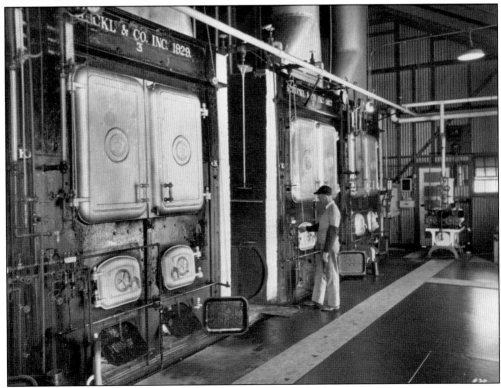

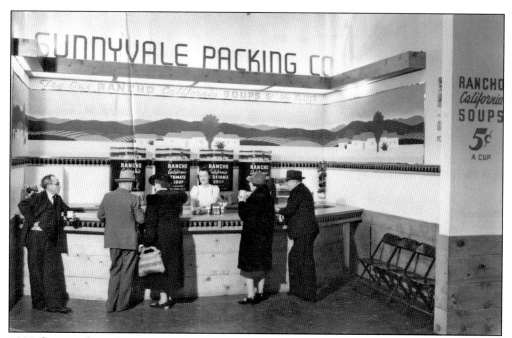

**1939 GOLDEN GATE INTERNATIONAL EXPOSITION.** Sunnyvale's Schuckl Cannery had a display at the 1939 World's Fair, held on San Francisco Bay's Treasure Island to celebrate the completion of the Bay Bridge (1936), the Golden Gate Bridge (1937), and Treasure Island (1937). The Pageant of the Pacific showcased products of Pacific nations, and Schuckl sold servings of its Rancho California canned soup for 5¢ per cup. This image is from a 1939 postcard.

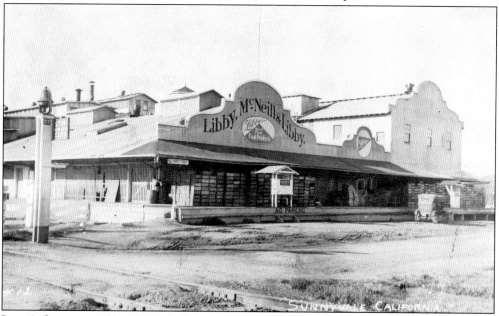

**LIBBY'S CANNERY.** Libby, McNeill, & Libby, a meatpacking company in Chicago, started its first fruit cannery in Sunnyvale. Construction of the plant was completed by 1907, and Libby's quickly became the town's largest employer, with a predominantly female workforce. This snapshot of the cannery was a popular postcard.

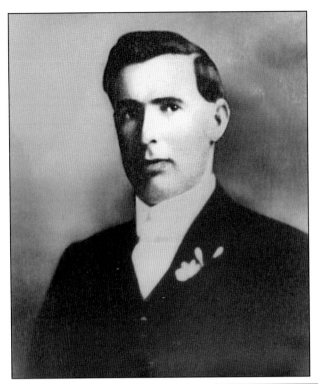

**NICK TIKVICA.** So much of the valley's success was due to the hard work of immigrants. Nicholas Tikvica emigrated from Eastern Europe in the very early 1900s and soon was buying up patches of land and planting fruit orchards. He eventually amassed over 800 acres of fruit orchards and was an important producer of quality cherries in the valley.

**PRESIDENTIAL THANKS.** It did not take long before TIK cherries were renowned throughout the country. This letter from the White House in 1935 expresses Pres. Franklin D. Roosevelt's appreciation for the fine fruit. Although it is unclear whether the handwritten signature was written by proxy or by the 32nd president's own hand, receiving such a letter from Washington, DC, must certainly have been a delight.

THE WHITE HOUSE
WASHINGTON

June 17, 1935.

My dear Mr. Tikvica:

    Mrs. Kahn has been good enough to bring to me those fine cherries you were so kind as to send to her for me. They are delicious and we are enjoying them.

    Many thanks for your friendly thought, and best wishes to you.

        Very sincerely yours,

        Franklin D Roosevelt

Nick Tikvica, Esq.,
Box 196,
Sunnyvale-Saratoga Road,
Sunnyvale,
California.

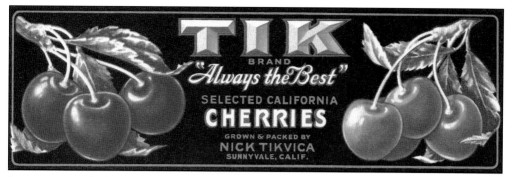

**LABEL ART.** In the heyday of fruit production, the finished fruit would be placed in wooden crates for transport to canneries or the market. The crates were often marked with gummed labels, beautifully designed and printed in vibrant colors. This vintage TIK cherry crate label, featuring red cherries and green leaves on a bright blue background, was typical of the era. As the industry moved towards cardboard boxes with black stamped imprints (such as the box being packed for shipment by Lester Tikvica, below, around 1950), the charming labels became collector's items.

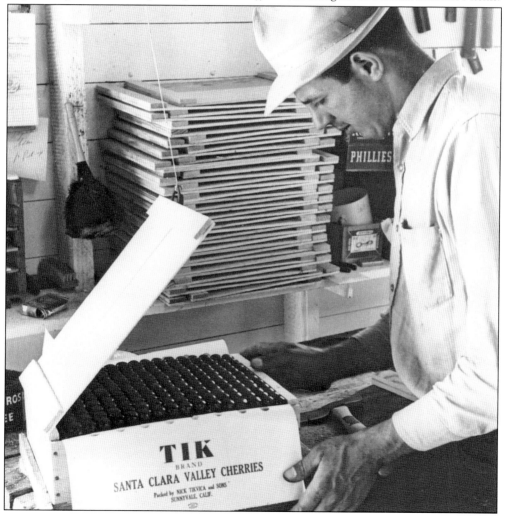

**EARLY BIOTECH: WILLSON'S WONDER WALNUTS.** Frank Chapman Willson came to California in 1886 from North Dakota, and around 1912, he established a nursery at El Camino Real and Pastoria Avenue in Sunnyvale. He developed an unusually large type of walnut—up to five inches in diameter—that became world-famous. The walnuts were painted white to protect them from excessive heat and to make them appear even larger.

**CARRYING ON THE TRADITION AND MORE.** Frank Willson's son, Harold Orvis Willson, who had been riding horses and driving tractors since grammar school, took over the walnut business upon his father's death. Root fungus and encroaching nonagricultural development eventually forced him to move his operations to Gustine in California's Central Valley. Perhaps for marketing reasons, the name often appears with the more common spelling of Wilson.

**WILLSON RANCH VEHICLES.** The Kleiber truck on the left was manufactured in San Francisco and purchased in 1918. Incredibly, it was driven to Sunnyvale by a very young Harold Willson for his father. The account written by his mother on the back of this photograph reads: "Harold at age 13 did not have a driver's license. The salesman went across the street and got a license for him. . . . [Harold] didn't know how to drive but drove the truck home."

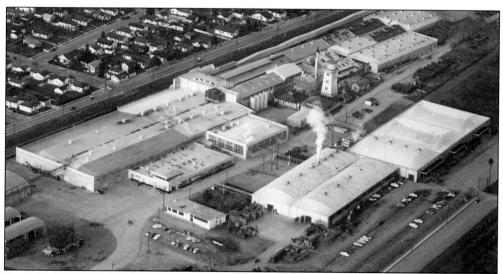

**LIBBY, MCNEILL, & LIBBY CANNERY AROUND 1950.** The canneries were large campuses, and often, whole families worked there in different capacities. The plant, located along the railroad tracks, was the world's largest fruit cannery by 1922. Libby's was purchased by Nestle Foods in 1971 and closed by the early 1980s. The plant was converted to the Sunnyvale Industrial Park in 1985.

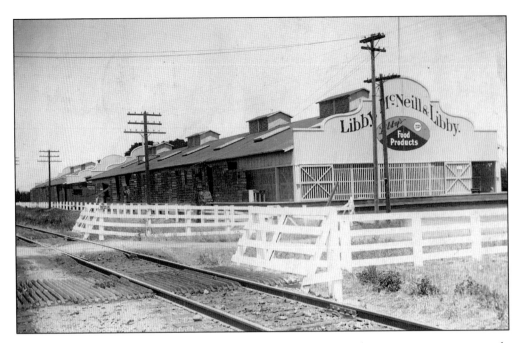

**WRITING HOME FROM THE CANNERY, 1909.** Postcards of Sunnyvale canneries were commonly used by employees when writing to friends and loved ones. Sunnyvale's Libby's and Schuckl plants were the largest such operations on the West Coast until the 1950s and attracted large numbers of both permanent (predominantly male) and seasonal (female) workers. On-site temporary cottages and daycare facilities for children were often provided, as were reduced train fares for "commutation" (as it was called by the local paper in 1908) from surrounding cities. The back of this postcard tells of long days at the prune packinghouse. Sent for 1¢ on October 2, 1909, it reached its recipient with only a name and city for an address.

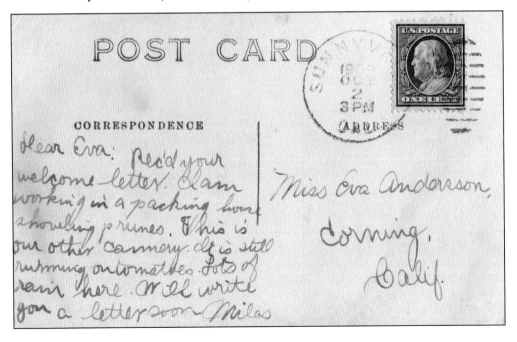

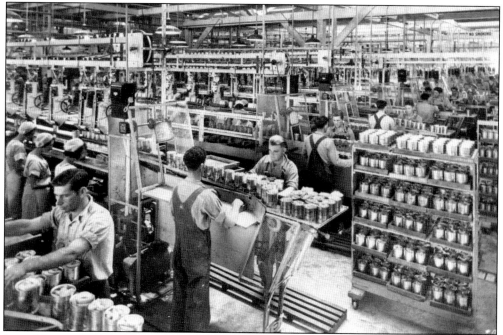

**IRON MEN OF THE CANNERIES.** Although women performed the lion's share of sorting and packing work at the large canneries, men worked the line also. The top and bottom images are from Libby's and Schuckl, respectively. In the late 1800s, men made up about one-fifth of the cannery workforce, primarily as can makers, cappers (can sealers), and processors (fruit cookers). The canning process was mostly mechanized by 1920, and men thereafter worked primarily in the warehouse, in shipping, and as foremen. The "unskilled" labor of fruit cutting, pitting, and sorting—performed exclusively by women—was never mechanized.

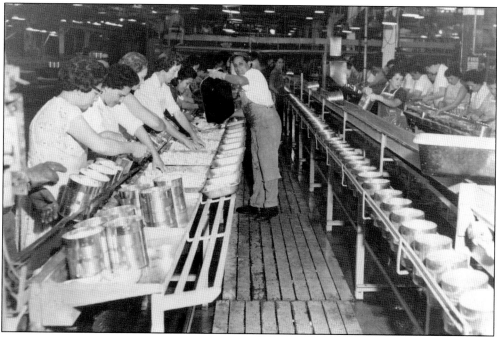

**CAL CAN DEMOLITION.** By the early 1980s, increasing housing, water, and sewer costs had made the canneries uneconomical. After closing its doors, Cal Can (originally Schuckl) was demolished and converted to apartments. Evelyn Avenue (apparently laid down in an S around cannery properties) can be seen curving to the southeast, while the buildings of the former Hendy Iron Works are visible at upper left.

**END OF AN ERA.** Like Cal Can, the Libby's cannery would soon be history. Here, Leonard Alamedo (left) and Emilio Diaz prepare Libby's machinery for auction on December 7, 1983, to make way for condominium construction. Despite the toxic nature of the area's computer manufacturing, canneries were considered dirtier, so housing and electronics were considered an improvement. Electronics plants would suffer similar fates a decade later. (Courtesy Patricia Hernández.)

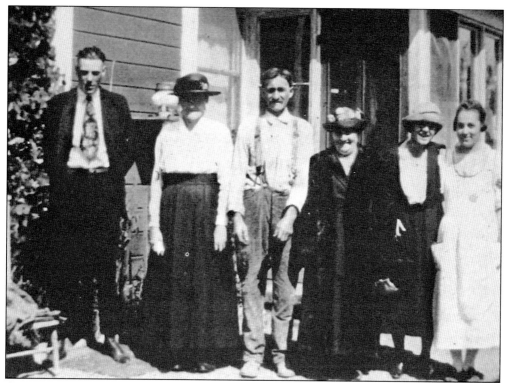

**OLSON FAMILY AT MATHILDA AVENUE AND EL CAMINO REAL, 1919.** Carl Johan Olson emigrated from Sweden in 1888 before marrying Hannah Merk and settling in Sunnyvale in the early 1900s. The family homestead was built in 1918 for just $275. Pictured from left to right are son Ruel Charles Olson, Hannah (Merk) Olson, patriarch Carl Johan Olson, Mrs. Merk, her daughter Goldie Christianson, and Carl Johan Olson's daughter Elsie Olson Kay.

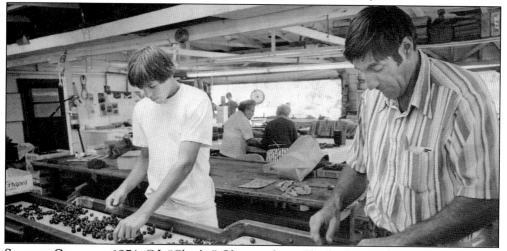

**SORTING CHERRIES, 1974.** C.J. "Charlie" Olson and son Charlie Jr. sort cherries at the family's fruit stand at El Camino Real and Mathilda Avenue while Charlie Sr.'s mother, Rose (right), and longtime employee Teresa Veloz (left) work in the background. The business was started by Rose in 1933; the cherry-sorting belt was bought secondhand in the 1960s by Charlie's father, Ruel Olson. Both still operate today. (Photograph by Bob Andres.)

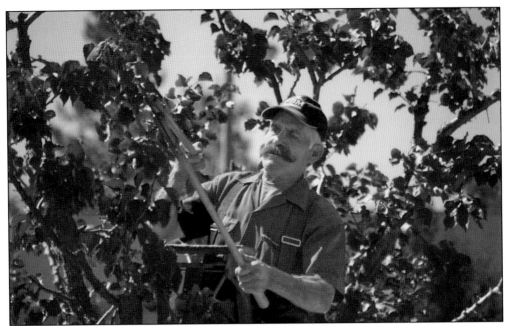

**ORCHARD'S LAST STAND, 2010.** Jesse Torres prunes apricot trees at Sunnyvale's Orchard Heritage Park. Surrounded by apartments and the community center, the 10-acre orchard is still zoned as farmland, and the fruit grown there each year by longtime orchardist Charlie Olson is sold to local residents at harvest time. The historic Bianchi family barn (relocated from San Jose), interpretive displays, and a state-of-the-art museum adjoin the orchard.

**LIBBY'S CANNERY WATER TOWER, 1985.** When the original 1907 tower was replaced in 1965, its replacement was made over as a fruit cocktail can. It was the only structure to survive demolition of the cannery. Shortly after this image was taken, the can was repainted by Silicon Valley artist Anita Kaplan, this time with the striking 1935 Libby's Fruit for Salad design. It is now a Sunnyvale Heritage Resource.

# *Three*

# INDUSTRIAL INNOVATION AND EARLY ELECTRONICS

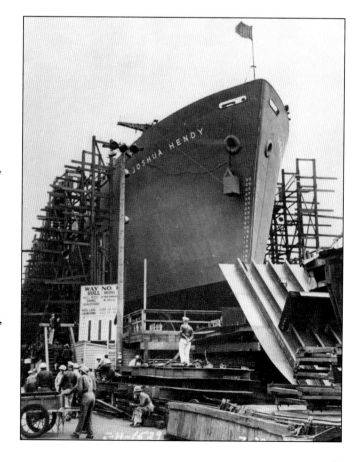

**A PROUD SHIP.** The Joshua Hendy Iron Works was a major wartime employer in Sunnyvale, manufacturing ship engines and other heavy equipment during World War II. In recognition of the company's contributions to the nation, a Liberty ship was named after the founder of the works. The SS *Joshua Hendy* was constructed in 1941 in 37 days at Permanente Metals Kaiser Shipyard No. 1 in Richmond, California. Crew accounts indicate she sailed to South Africa, South America, the eastern US seaboard, and the Caribbean during the war. Built to last only five years, she lasted nearly 20 but was scrapped in 1961.

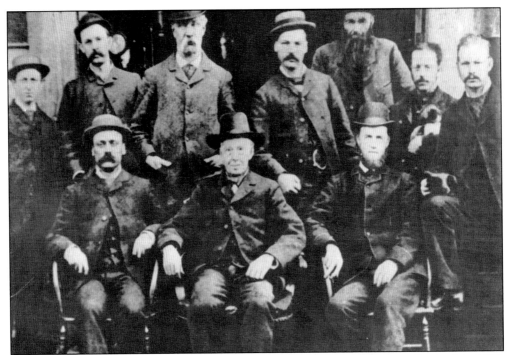

**Joshua Hendy around 1880.** Joshua Hendy (seated in center) was born in England in 1822, immigrated to the United States, trained as a blacksmith, and later joined the California Gold Rush. He established his Hendy Iron Works in 1856 to produce mining equipment. He died in 1891, and his nephews Sam and John Hendy (seated left and right) moved the company to Sunnyvale in 1906 after the great San Francisco earthquake.

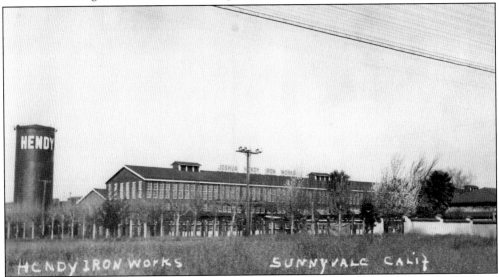

**Big Yard, 1907.** The Hendy Iron Works was one of California's first foundries and heavy machine shops, renowned for enormous mining and construction equipment: ore crushers, hydraulic gravel lifts, and the "Hurdy Gurdy," a tangential water wheel used to drive mining equipment. Hendy's machines were used on the Panama Canal and Hoover Dam projects. Note the early electrical pole on the lawn and dozens of telegraph lines in the foreground.

**THE LAMP POST ON OAK COURT.** The iron works also built municipal fixtures such as street lamps, hydrants, and manhole covers. Many Hendy lampposts still stand in the city of San Francisco, including on the Golden Gate Bridge, and a few also still exist in Sunnyvale. Contractor Burt Matthews placed this lamp in the center of the city's first cul-de-sac in 1937, and bicyclists have been zooming around it ever since.

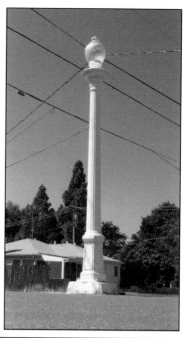

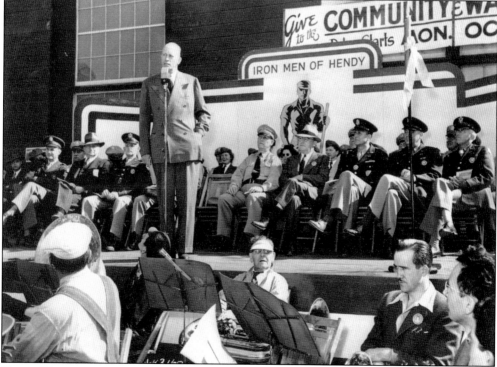

**HENDY WORKS MOORE.** Industrialist Charles W. Moore, here firing up workers at a World War II rally, purchased Hendy Iron Works in 1940 with the financial backing of the "Six Companies," the construction consortium that built the Hoover and Grand Coulee Dams. An imposing six foot six, he was dubbed "America's No. 1 Can Do Man" for turning Hendy into a 7,500-employee machinery giant. Moore sold the works to Westinghouse Corporation in 1947.

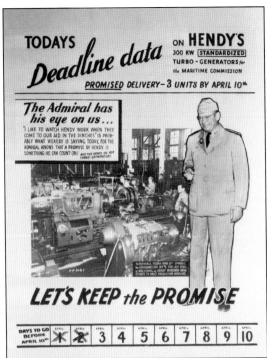

**HENDY IRON WORKS WORLD WAR II POSTER.** Inspirational posters such as these were used to energize workers for the war effort. Here, the men and women of Hendy are reminded of production promises made to US Navy admiral Howard Vickery. The admiral was head of the wartime Emergency Shipbuilding Program, which produced 6,000 ships in five years, in part through Hendy's production of Liberty ship engines.

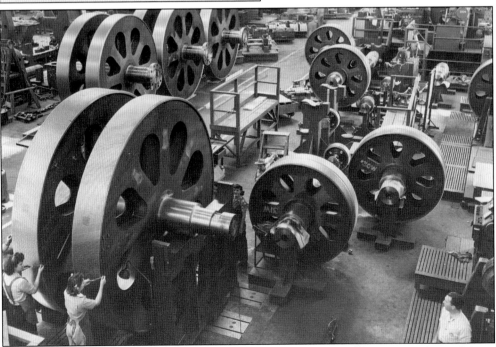

**WOMEN'S WORK, 1942.** Although iron works publicists touted its "Iron Men of Hendy" workforce, many women were hired to meet wartime production quotas. Here women work on gearboxes for steam reciprocating engines in the works' enormous machine shop. Spurred on by the iconic Rosie the Riveter, female employees increased by over 50 percent during the war, although most women had to give up their positions at war's end.

**HENDY BADGE CHECK, AUGUST 1943.** Employee identification tags in the early 20th century usually took the form of stamped metal badges. Security was considered especially important during the war years; here, a female security officer instructs a Hendy Iron Works employee in proper badge placement.

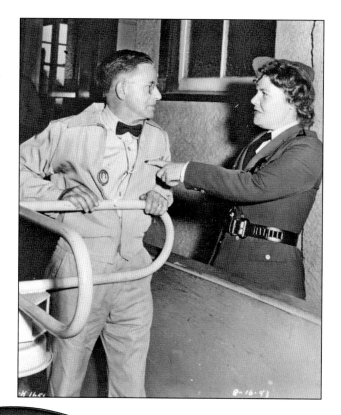

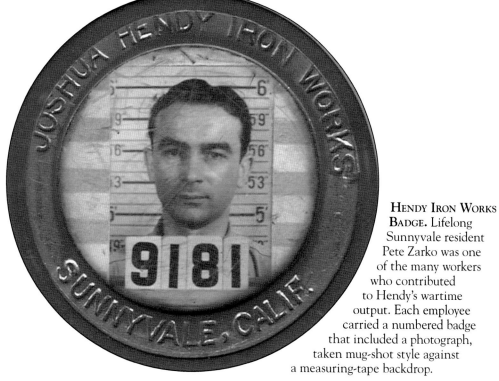

**HENDY IRON WORKS BADGE.** Lifelong Sunnyvale resident Pete Zarko was one of the many workers who contributed to Hendy's wartime output. Each employee carried a numbered badge that included a photograph, taken mug-shot style against a measuring-tape backdrop.

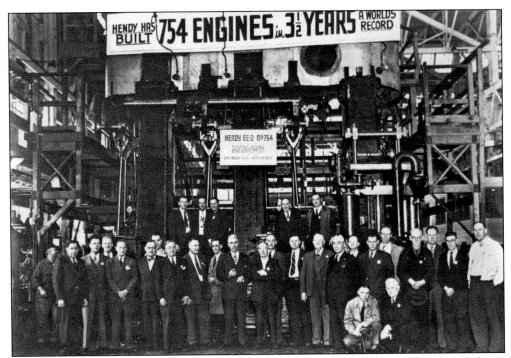

**WORLD RECORD.** Hendy had built marine engines for World War I cargo ships, which led to a contract to build World War II Liberty ship steam engines. Innovations in assembly-line techniques introduced by Charles Moore made the works the largest supplier of Liberty ship engines, equipping about one quarter of the fleet. Hendy's "Iron Men" (and women) shaved production to just 40 hours per engine, and the company delivered 754 units.

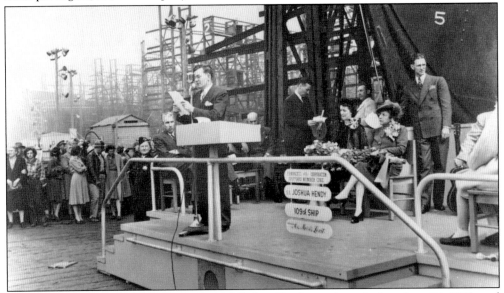

**LIBERTY SHIP LAUNCH.** The Liberty ship SS *Joshua Hendy* was launched on June 24, 1943, and delivered on July 31, 1943, at a cost of about $1.8 million. As shown on the podium sign, the *Hendy* was the 109th ship produced at the Permanente shipyard. Hendy Iron Works public relations official Joseph F. Donovan was on hand to say a few words during the launching ceremony.

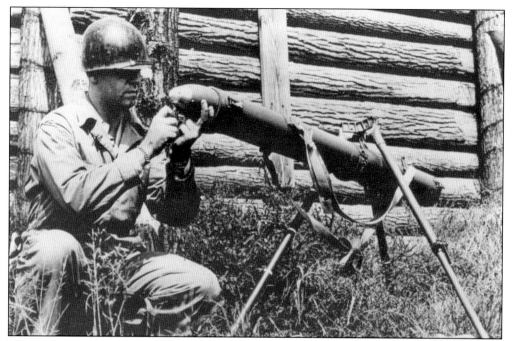

**HENDY AT WAR.** Hendy Iron Works also produced rocket launchers, which fired 4.5-inch rockets. Here, a soldier pulls the safety pin to arm the rocket. Early models were disposable, using plastic tubes. The plastic was later replaced by a metal alloy, allowing the launcher to be reused. As the Westinghouse Corporation after the war, the company continued to manufacture missile systems and large military guns. (Courtesy Westinghouse.)

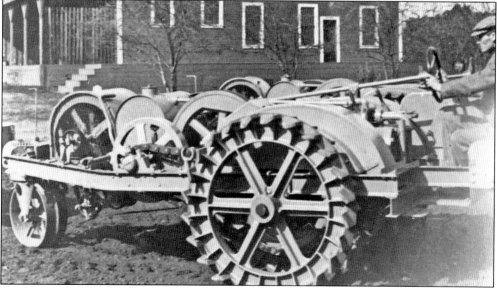

**TOE-HOLD TRACTOR.** Alfred Johnson and James McCollough formed the Johnson Tractor company in Sunnyvale in 1905. The Toe-Hold model resulted from experiments in which Johnson and his brothers placed horseshoes around tractor wheel rims for better traction. The company was purchased by Hendy Iron Works around 1907, and tractors were made in Sunnyvale until Hendy sold the design to a Michigan company in 1913. (Courtesy CHC and Allen Rountree.)

**Wooldridge Manufacturing Company around 1940.** Wooldridge manufactured heavy earth-moving equipment from its plant near Murphy Avenue from the 1930s through 1958. Wooldridge sold self-propelled tractor-scrapers called "Terra Cobras" that were used throughout the United States in the 1940s and 1950s. The company moved to Sunnyvale for its "low taxes, excellent shipping facilities, and freedom from strife of every description." It took over the failed Goldy Machine Company site.

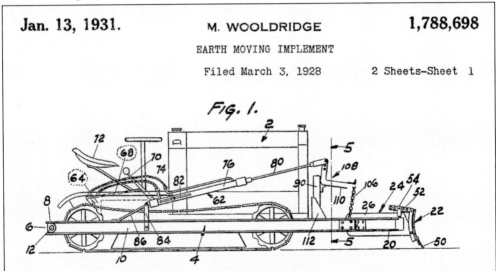

**First Patent.** Mack Wooldridge, founder of Wooldridge Manufacturing Company, patented a number of heavy equipment innovations in the 1930s through 1950s. His first patent, for a motorized scraper, was issued in 1931. The company was acquired by aerospace manufacturer Curtiss-Wright in 1958; neighboring Westinghouse, which had bought the Hendy Iron Works in 1947, purchased the Wooldridge buildings and its 11 acres in 1959.

*A.W. Bessey*

**FATHER AND SON ENTREPRENEURS.** Albert W. Bessey (right) founded the Jubilee Incubator Company. It became one of early Sunnyvale's largest businesses, built on land purchased from Murphy daughter Mary Ann Carroll. A passionate birder, he published a pamphlet describing "Chickens Properly Hatched" and kept a huge aviary with 76 bird varieties from 11 countries. He also provided startup funds for the city's first electronic manufacturing business: the Radio Shop, founded by his son, Arthur E. Bessey (left).

**JUBILEE-BUILT BROODER HOUSE AROUND 1910.** The Jubilee Incubator Company manufactured all manner of poultry brooder houses, incubators, and supplies. A brooder house this size would have been used in the commercial production of chicks. The firm gained international acclaim and exported its products to numerous customers worldwide. Eugene T. Sawyers wrote in his 1922 *History of Santa Clara County* that the Jubilee name was "like sterling."

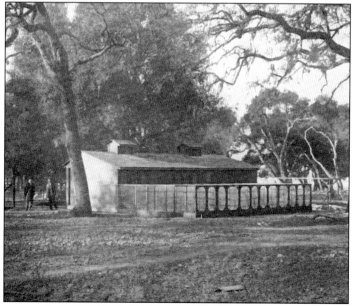

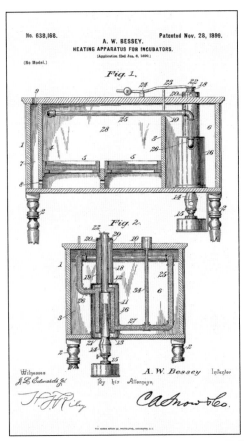

**AGRICULTURAL HIGH TECH.** Albert W. Bessey was not only a businessman, he was also an inventor. His patented poultry incubator design replaced the usual internal kerosene lamps with externally supplied hot water. This innovative design provided gentle, even heating and greatly reduced the risk of fire in chick hatcheries. A surviving incubator—an extremely rare find on loan from the Twist family—is on display at the Sunnyvale Heritage Park Museum.

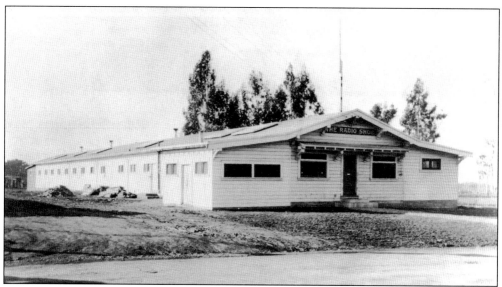

THE RADIO SHOP AROUND 1922. This is the only known photograph of electronics pioneer Arthur E. Bessey's firm, located at 229 North Sunnyvale Avenue. Called "perhaps the first Silicon Valley startup" by Koning and business writer Michael S. Malone, the shop began by making radio instrumentation and components for amateur broadcasters before manufacturing up to 150 home radios per day, employing 125 people.

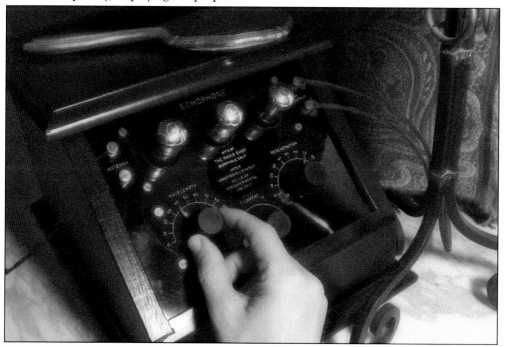

ECHOPHONE MODEL V-3. One hundred thousand of these battery-powered, three-tube regenerative broadcast band radio receivers were manufactured in Sunnyvale during the first few years of the 1920s. Legend has it that Arthur Bessey was able to use Edwin H. Armstrong's regenerative receiver patent after buying him a beer at a Chicago radio convention. The junior Bessey went on to serve as the first West Coast director of the American Radio Relay League (ARRL).

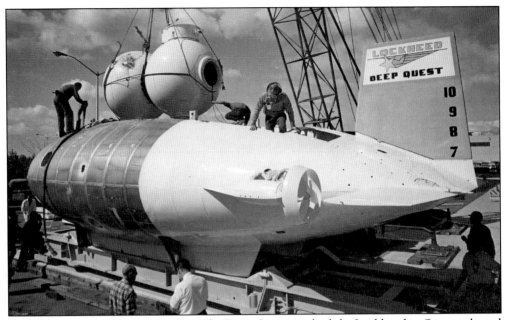

**DEEP QUEST RESEARCH SUBMARINE.** The Deep Quest was built by Lockheed in Sunnyvale and launched in 1967. The 39-foot, 50-ton welded aluminum vessel performed a then-record dive of 8,310 feet in 1968, planting a US flag on the Pacific Ocean floor. It could travel at 4.5 knots and stay submerged for 24 hours. Deep Quest was involved in numerous ocean-floor exploration and wreckage survey missions until its retirement in 1980.

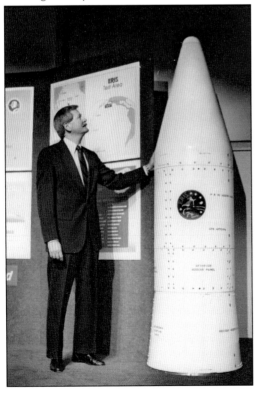

**ERIS MISSILE, 1985.** Attracted by Moffett Field and an educated workforce, Lockheed Missiles and Space Systems became a major Sunnyvale employer during the Cold War. Lockheed received a contract in 1985 to build the Exoatmospheric Re-entry Interceptor Subsystem (ERIS) missile as part of President Reagan's Strategic Defense Initiative (Star Wars). Although the global defense shield was never realized, the technology Lockheed developed is still used in missile guidance systems.

**TRIDENT MISSILES AROUND 1988.** Trident I (right) and II missiles, developed by Lockheed, are shown with attached aerospikes. The aerospike extends from the Trident once it has cleared the water after a submarine launch, improving the missile's flight aerodynamics. Trident I missiles were used from 1979 to about 1990. Trident IIs are slated to be in service until at least 2027 on US Ohio-class submarines.

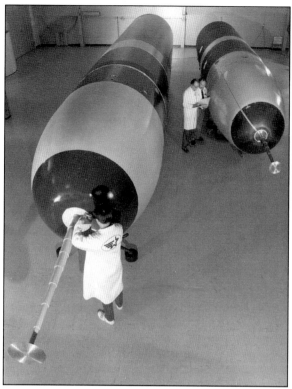

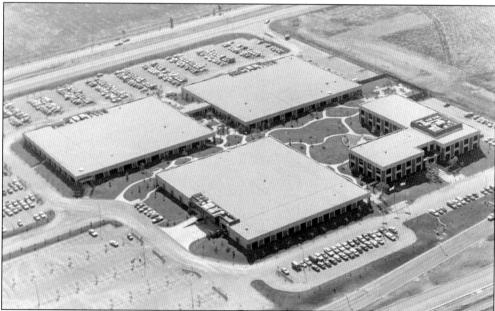

**AMDAHL CORPORATION, 1970s.** As computers became more important in industry, Sunnyvale's high-tech sector grew. Superstar engineer Gene Amdahl left IBM in 1970 to produce his own line of faster and cheaper mainframe computers. Now part of Fujitsu Corporation, the offices are still located between Central Expressway (top) and Arques Avenue. Amdahl is known in computer science for Amdahl's Law of parallel computing.

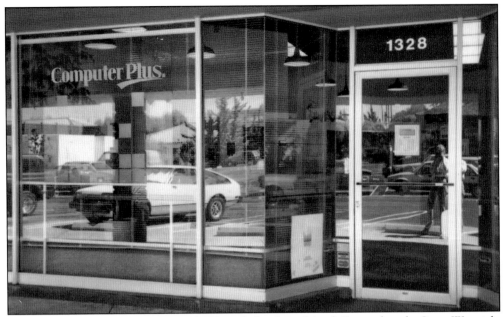

**COMPUTER PLUS AROUND 1986.** Mark Wozniak, brother of Apple Inc. cofounder Steve Wozniak, started this computer store in 1978 in a strip mall at Fremont and Mary Avenues. Often Steve Wozniak and Steve Jobs would drop by, and the shop became a focal point of the personal computer revolution. Local kids were allowed ample access to the store's computers; many went on to high-tech careers. (Courtesy Mark Wozniak and Lucy Applebaum.)

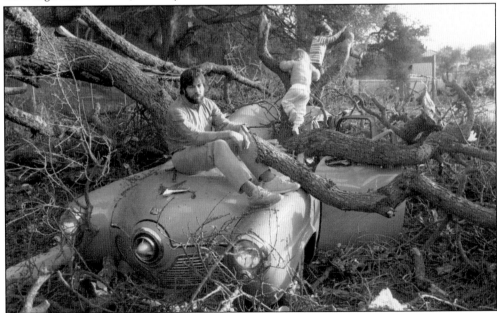

**SMALL SETBACK.** Steve Wozniak sits atop his ruined 1951 Studebaker in February 1987 while his children explore the wreckage. Wozniak, who grew up in Sunnyvale before founding Apple in 1976, was working at his new startup, CL 9, when a large oak tree fell on the classic car. Having just resigned from Apple the week before, "Woz" was said to have remarked, "At least it wasn't an Apple tree!" (Photograph by Dana Downie.)

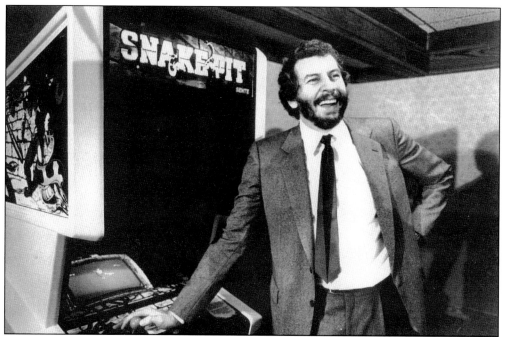

ATARI FOUNDER NOLAN BUSHNELL, 1984. Atari was also homegrown in Sunnyvale. Bushnell launched the video game craze when, in 1972, he placed a Pong prototype in Andy Capp's Tavern (now Rooster T. Feathers). By the next morning, patrons were lined up around the block to play, and the video game revolution was on. Bushnell went on to start Senta (makers of Snake Pit) and Pizza Time Theater (now Chuck E. Cheese's).

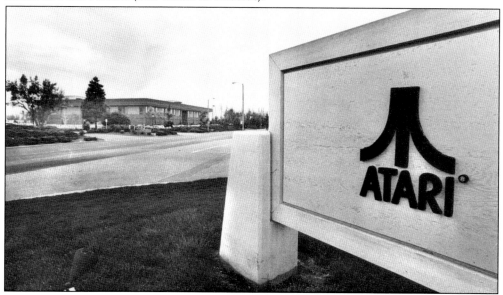

ATARI WORLD HEADQUARTERS, SUNNYVALE, CALIFORNIA. Atari was the undisputed leader in both coin-operated and home video gaming from the early 1970s until 1983, when a series of internal miscues and Japanese competition proved to be its undoing. A generation of high school kids longed to work at this Silicon Valley mecca. Many a Friday-night dumpster-diving urban safari resulted in a bounty of spare video game parts or technical printouts.

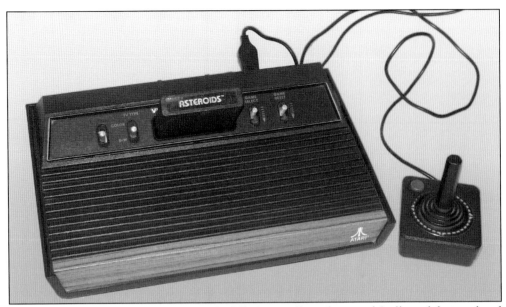

**ATARI 2600 VIDEO COMPUTER SYSTEM (VCS).** Internally code-named Stella and designed and (initially) built in Sunnyvale, this was the first true console game. Its purpose-built Television Interface Adapter (TIA) chip, designed by Jay G. Miner, was one of the first true application-specific integrated circuits. Savvy marketing and an impressive catalogue of games ensured that there was simply no competition—until Nintendo. (Courtesy Dave and Sarah Lyons.)

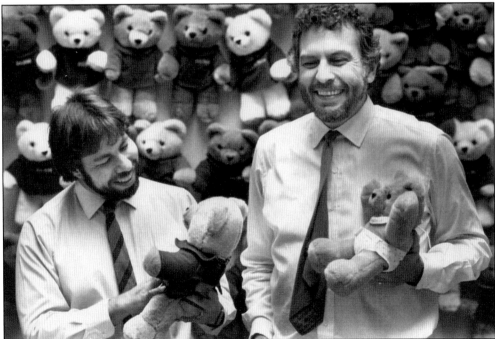

**POWER DUO.** Valley legends Steve Wozniak and Nolan Bushnell are pictured at a press conference in 1986 to announce a joint venture and merger of their respective companies, CL 9 and Axlon. Behind them are Axlon's popular A.G. ("Almost Grown") talking bears. The merger never happened, however, and Axlon was eventually sold to Hasbro.

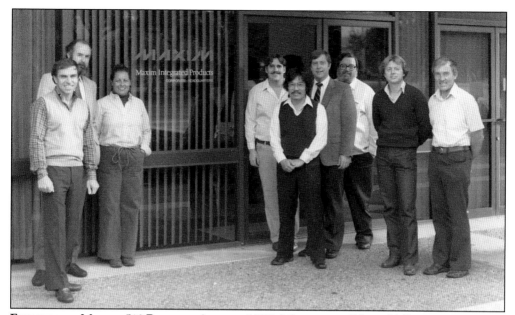

**FOUNDING OF MAXIM, 510 PASTORIA AVENUE, 1983.** Like so many Silicon Valley startups, Maxim was founded by a handful of engineers who saw an unfulfilled market need and quit their employers to form a company of their own. The company started in a former bank office but grew rapidly by specializing in mixed-signal chips. Maxim is a quintessential Sunnyvale success story; it has grown to over 8,000 employees.

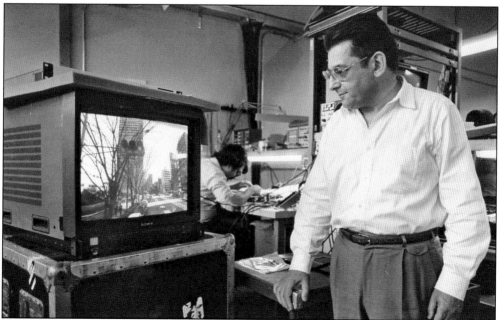

**FAROUDJA LABS, BENICIA AVENUE, 1987.** Yves and Isabel Faroudja started their company in 1971, specializing in picture enhancement technology. He may not be a household name, but Faroudja's video processing algorithms and products are found in TVs, DVD players, and other home and professional video equipment. Faroudja received over 65 patents and won three Emmys for his innovations. The firm is now part of ST Microelectronics. (Courtesy Edward Ledesma.)

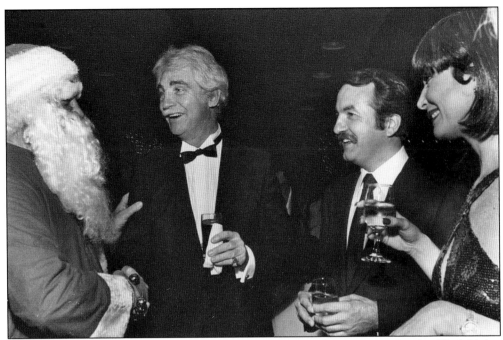

**An AMD Christmas, 1980.** Advanced Micro Devices president Jerry Sanders (middle left); his wife, Tawny; and Sven Simonsen greet Santa Claus. Sanders and Simonsen helped found AMD in Sunnyvale in 1969. The flamboyant Sanders famously said "people first, products and profits will follow." He set the standard for extravagant parties and prizes; he once gave an employee $1,000 per month for 20 years as the prize of a company-wide raffle in celebration of a sales goal. Sanders retired in 2002.

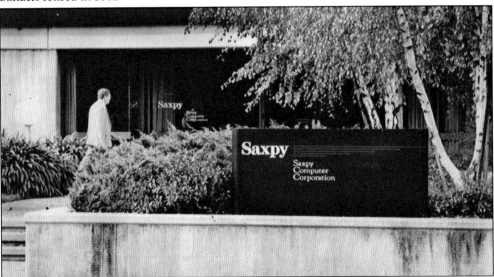

**Cold War Espionage Caper.** On October 23, 1987, FBI and US Customs agents arrested Saxpy engineer Kevin Anderson, former engineer Ivan Batinic, and Batinic's brother Stevan. The Batinics had helped Anderson steal plans for Saxpy's Matrix 1 supercomputer, which could track military submarines and missiles, for sale to the Soviet Union. The parties involved ended up in jail. Saxpy did not fare much better; it was sold to competitor Cray within a few years.

**Silica Tiles.** Lockheed Missiles and Space Division began researching thermal insulation in 1957 and by 1968 had developed the glass fiber tiles central to the space shuttle's thermal protection system. The fragile bricks were used in all five orbiters, which together flew over 130 missions while withstanding temperatures of up to 2,300° Fahrenheit. The loss of *Columbia* in 2003 resulted from damage of reinforced carbon-carbon (RCC) panels, also built by Lockheed.

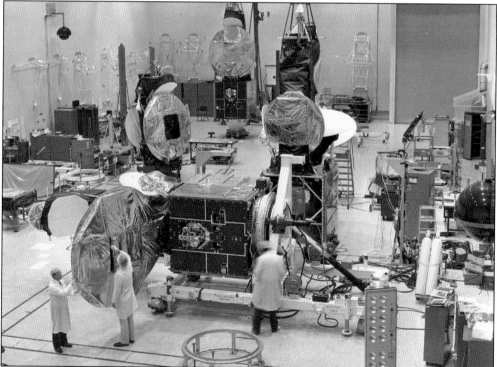

**Ford Aerospace, Early 1980s.** The Ford Motor Company had a space systems division that built sophisticated control systems and space hardware for the military. The Sunnyvale unit had contracts with the Air Force to build satellites and operate communication stations for military satellite and space shuttle programs. The company was sold in 1990 to Loral Corporation and became Space Systems/Loral, which continues to build satellites in neighboring Palo Alto.

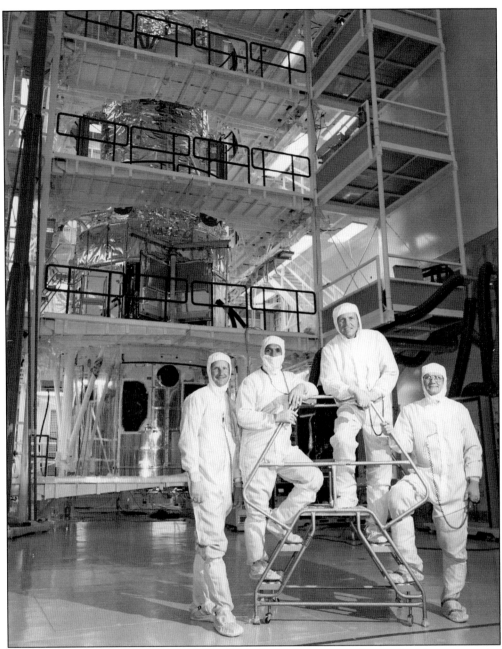

**HUBBLE VISION, AUGUST 1986.** Lockheed built the Hubble space telescope's carbon-composite frame, which houses the astronomical instruments, as well as its insulated aluminum shell. The company then spent two years assembling instruments into the telescope to prepare for an October 1986 space shuttle launch. Unfortunately, the *Challenger* disaster in January of that year delayed the launch until April 1990. In the meantime, the ready-to-go observatory had to be kept in a cleanroom filled with nitrogen gas and continually tested. Keeping Hubble ready reportedly cost NASA an astounding $7 million per month. Posing at Lockheed with the telescope are, from left to right, astronauts Steve Hawley, Charles Bolden, Loren Shriver, and Bruce McCandless, four of the five astronauts on STS-31, the shuttle mission that finally launched Hubble into space.

# *Four*

# A Growing Community

**First Sunnyvale Lumber Mill, 1906.** By the early 20th century, Sunnyvale's industrial sector was rapidly expanding: the Hendy Iron Works, Madison and Bonner Fruit Packers (later Del Monte), and Libby, McNeill, & Libby all now made their home here. Much of the lumber for these factories, as well as the residential housing that followed, was supplied by the Parkinson Brothers Lumber Company (above), established in the late 1800s.

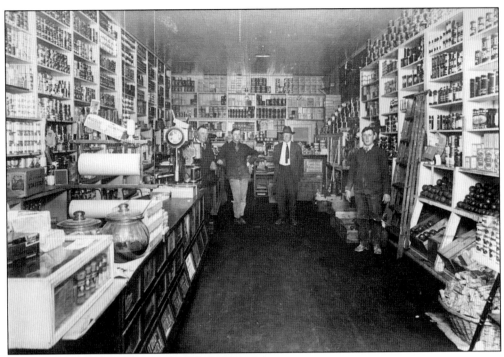

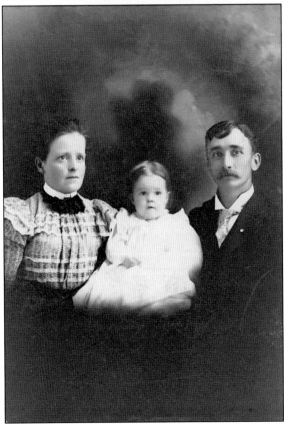

**FAMILY GROCERY.** By the turn of the century, hundreds of people lived in the village, which was first known as Murphy's Station (or just Murphy) and later as Encinal. It was renamed Sunnyvale in 1901. This small but well-stocked grocery was located at the corner of Murphy and Evelyn Avenues and was operated by the Green family. (Courtesy Kay Peterson.)

**GREEN FAMILY GROCERS AROUND 1900.** The Green family was Edith, Dennis, and their daughter, Doris. As a young woman, Doris struck up a friendship with future husband Marden Carlson during a summer trip to Sweden. After exchanging letters and postcards for a couple of years, Doris married Marden, and they settled in Sunnyvale to raise a family.

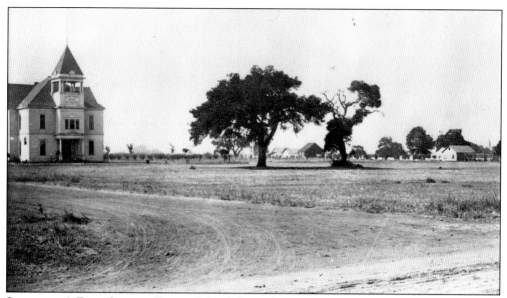

**SUNNYVALE'S FIRST SCHOOL.** Encina School, located on Washington Avenue near Frances Street in the then town of Encinal, was opened in the fall of 1899 with one teacher for all grades: Jenni Cilker of Los Gatos. Unfortunately, the beautiful schoolhouse was damaged in the 1906 San Francisco earthquake, and the second story had to be removed. The school was later expanded and called the Sunnyvale School.

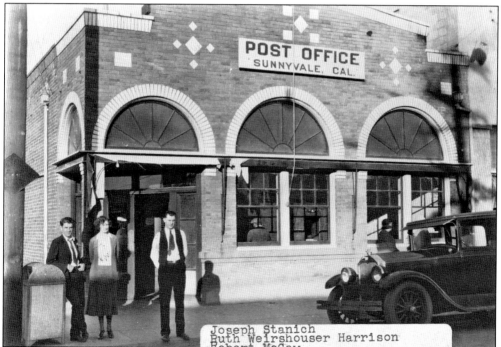

**SUNNYVALE POST OFFICE, 1932.** Sunnyvale's first dedicated post office building was constructed in 1917 and was located at 127 West Washington Avenue. Here, from left to right, assistant postmaster Joseph Stanich and clerks Ruth Harrison and Robert McCaw enjoy a sunny day on January 13, 1932. The distinctive brick building survives today as the Italian restaurant Il Postale.

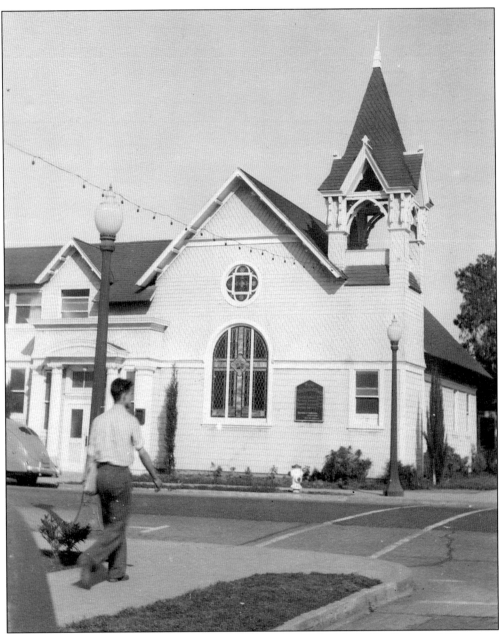

**Sunnyvale's First Church.** Sunnyvale's first church was the Methodist Episcopal Church of Sunnyvale built at South Murphy and McKinley Avenues. Developer Walter Crossman promised to donate land to the first church to build in Sunnyvale, and one spring Sunday in 1903, a young Rev. David Ralston heard that the Baptist minister J.S. Hayward had planned a parish meeting to ask for the land the very next day. Ralston rushed to meet with Crossman and also hurriedly organized all the Methodists to rally at the site. When the Baptists came for their meeting that next evening and saw the commotion, in Ralston's own words, the sight "was too much for them and they all went home, and we proceeded with our Methodist church." Crossman officially deeded the land to the Methodists on Wednesday April 1, 1903, for $10. The church, now the First United Methodist Church, moved to a new building on Old San Francisco Road in 1955.

66

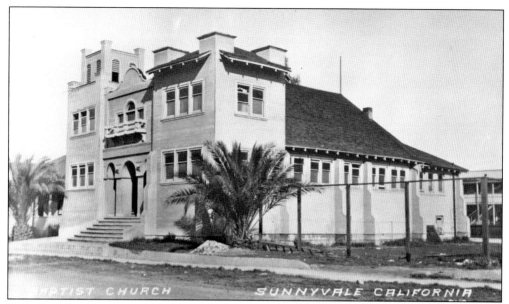

**Sunnyvale's First Baptist Church.** The cornerstone for the new Baptist church on Frances Street in Sunnyvale was laid on May 18, 1908, and the completed building was dedicated on August 9 of that year. The church included a worship space that could hold up to 400 of the faithful, as well as a number of classrooms. The building was destroyed to make way for the Sunnyvale Plaza in 1952.

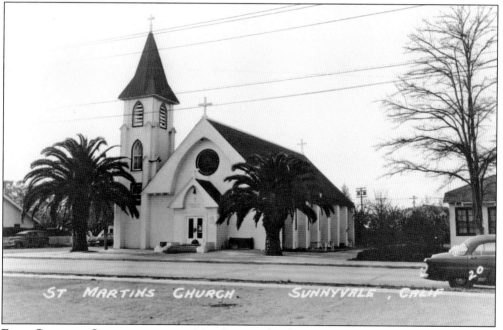

**First Catholic Church around 1940.** Sunnyvale's first Catholic services were actually held in 1850 at Bay View, where the Irish Catholic Murphy family had a room with an altar used by priests from the Santa Clara mission. The first dedicated Catholic church, St. Martin, was constructed in 1910 on Sunnyvale Avenue near Iowa Avenue. It was rebuilt on Central Avenue and Old San Francisco Road in 1961.

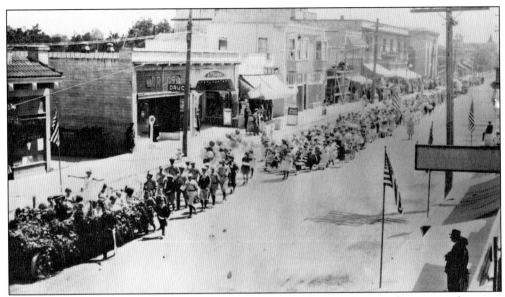

FOURTH OF JULY PARADE, 1923. Throughout the 1910s and 1920s, Sunnyvale continued to grow as a community, and it was a thriving town of 2,000 inhabitants when this holiday parade made its way down Murphy Avenue. Besides the float, bands, and troops of Scouts commonly found in hometown celebrations, this procession included a "pet parade," in which children marched with their favorite furry friends.

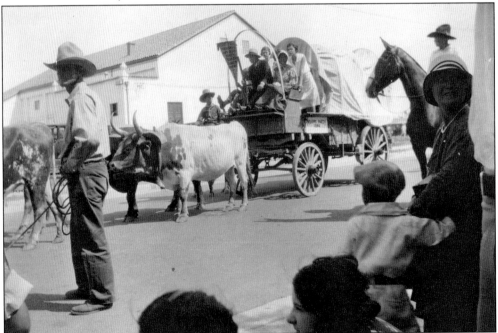

FOURTH OF JULY PARADE, 1931. One of the attractions of the 1931 parade was a reenactment of the 1844 Stephens-Murphy-Townsend wagon train party heading down Murphy Avenue. The theme that year was "On the Mission Trails," and the Independence Day festivities were cosponsored by the Sunnyvale Fourth of July Association and the Navy dirigible base. The then-new city hall building at McKinley Avenue can be seen in the background.

**MOVIE SCHEDULE FOR THE STRAND THEATER, 1927.** An adult ticket was 30¢, and loges (theater boxes) could be had for slightly more. The theater opened as the Strand and has been variously known as Blanco's Sunnyvale Theater, the Murphy Street Cinema, and the Palace through the years. It later housed the Forum nightclub.

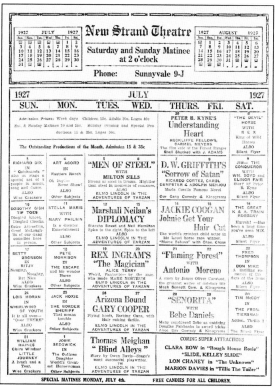

**REDWINE'S GARAGE, 257 SOUTH MURPHY AVENUE.** Sunnyvale native Pete Zarko operated this garage with his partner Willard Frazer during the 1930s. He joined the Hendy Iron Works with the outbreak of World War II but soon returned to his automobile roots, running a Shell service station on the northwest corner of El Camino Real and Mathilda Avenue until the property became part of the Sunnyvale Civic Center in 1977.

**Distillery Building of the Scott-Collins Winery, 1940.** Salvin and Angelina Collins came to Sunnyvale in 1879, planted 160 acres of grapes, and started a winery. After Salvin's death, Angelina married Emerson Wesley Scott, and by 1894, the Pebbleside Winery was producing over half a million gallons of wine and brandy annually. The winery later became the Pebbleside Poultry Farm. The distillery building is now a Historical Landmark.

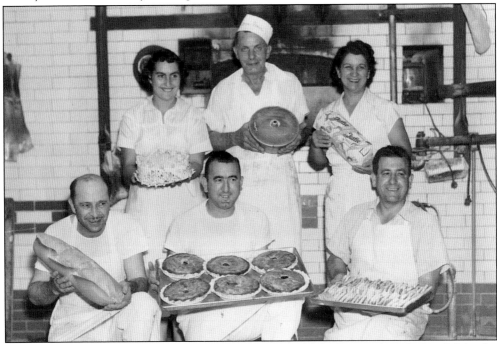

**Bakers from Spain, 1955.** Seijo's Depot Bakery was established in 1925 at 121 South Murphy Avenue, less than 100 yards from the train depot. From left to right are (first row) Benny Freeman, Faustino "Tino" Rodriguez, and Cipriano Gutierrez; (second row) Manuela Rodriguez, Ted Estenson, and Rose Gutierrez. Tino Rodriguez and Cipriano Gutierrez operated the business from 1951 to 1966. (Courtesy Kay Peterson and Manuela Rodriguez.)

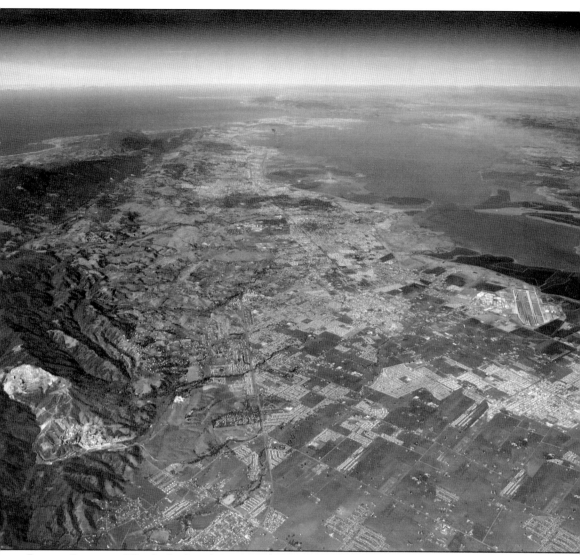

**IDEALLY LOCATED.** This high-altitude image, taken in 1957, shows the proximity of Sunnyvale to San Francisco and the Pacific Ocean. This sheltered valley with a Mediterranean climate and fertile soil made for an ideal place to settle and for businesses to thrive. In a 1930 marketing film to convince the Navy to establish a naval air station in Sunnyvale, US Navy strategist Rear Adm. Alfred. T. Mahan favorably compared Sunnyvale to Pearl Harbor, and also noted that the strategic mountaintop road overlooking the bay (Skyline boulevard) would be a perfect place for "mobile artillery." Other resources touted by the film included the exceptional weather (with little wind to buffet dirigibles), the nearby Palo Alto airport, and an educated workforce.

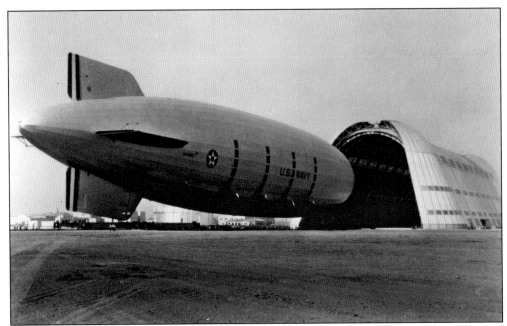

**USS Macon Entering Hangar One.** Naval Air Station Sunnyvale was dedicated April 12, 1933, and became the home of this rigid airship. Launched in Akron, Ohio, on April 21 of that year, the $2.5-million dirigible (along with the USS *Akron*) holds the record for the largest helium-filled airship ever built. Five Curtiss F9C-2 Sparrowhawk biplanes that could be launched and retrieved during flight were used for reconnaissance.

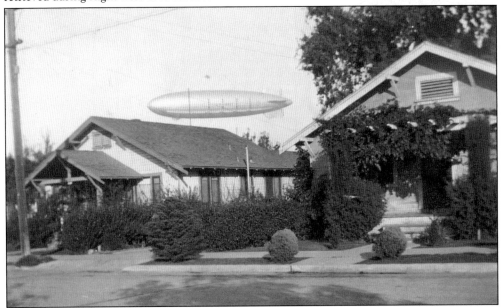

**USS Macon over Sunnyvale, 1934.** During the brief few years that the *Macon* flew, the giant dirigible frequently hovered over Sunnyvale. Airships have not been seen in these skies for 75 years, but in 2008, a private company began offering zeppelin tours of the San Francisco Bay Area from Moffett Field. On calm, sunny days, history repeats itself, although today's airships cannot match the *Macon*'s mammoth 784-foot length.

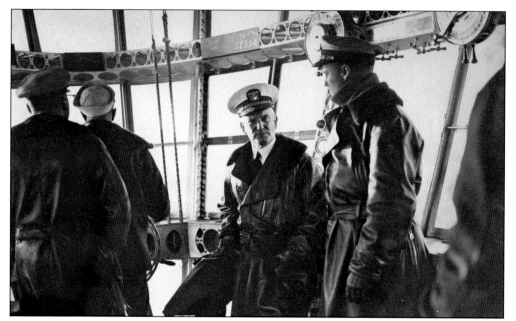

**REAR ADM. JAMES MOFFETT.** The admiral (center) is photographed with *Akron* skipper Charles Rosendahl during the *Akron*'s first official flight on November 2, 1931. Admiral Moffett was also on board when the *Akron*, a dirigible identical to the *Macon*, crashed in bad weather in the Atlantic on April 4, 1933. The admiral and 72 crew perished in that accident, and Naval Air Station Sunnyvale was renamed Moffett Field.

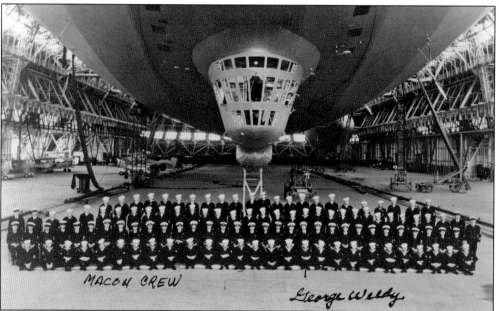

**USS MACON CREW AROUND 1934.** The *Macon*'s most famous exploit was Lt. Comdr. Herbert Wiley's navigation triumph of surreptitiously locating the Navy cruiser USS *Houston*, carrying President Roosevelt, in the Panama Canal during a war games exercise. A furious naval fleet commander Joseph M. Reeves tried to discipline Wiley, but the president recognized the dirigible's value as a scouting vessel, and Wiley was promoted to commander.

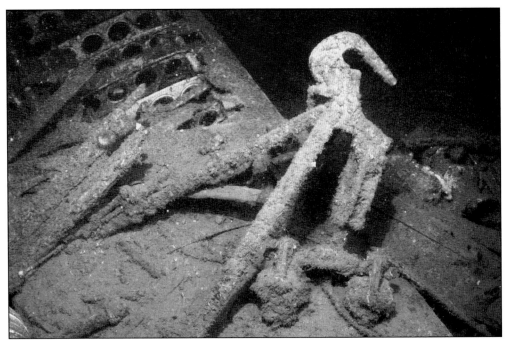

MACON FOUND! Like the *Akron*, the *Macon* crashed in bad weather after only a few years of service. It went down during a storm off California's Point Sur on February 12, 1935, with the loss of two crewmembers. The *Macon*'s remains were found in 1,500 feet of water in 1990. This image of the skyhook from one of its Sparrowhawk biplanes was taken during a 2006 dive. (Courtesy NOAA/Monterey Bay Aquarium Research Institute.)

MOFFETT FIELD BASE CHAPEL AROUND 1946. Moffett's Station Chapel, dedicated on September 23, 1945, includes an innovative revolving altar that allows for Protestant, Catholic, Jewish, and nondenominational services. The sanctuary is beautified by 12 stained-glass windows that were completed in 1956. The panels include religious themes and also incorporate dedications to Navy squadrons and servicemen who have died in service to their country.

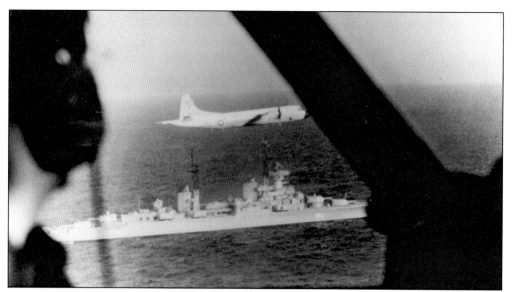

**P-3 Orion in Action.** The Lockheed aircraft flying out of Moffett Field served on long-range anti-submarine patrols to safeguard the western coast of the United States. With a crew of 12, the P-3 has a 5,000-mile range and can stay aloft for more than 15 hours. These craft were responsible for patrolling a 93-million-square-mile swath of the Pacific from Alaska to Hawaii. (Courtesy U.S. Navy.)

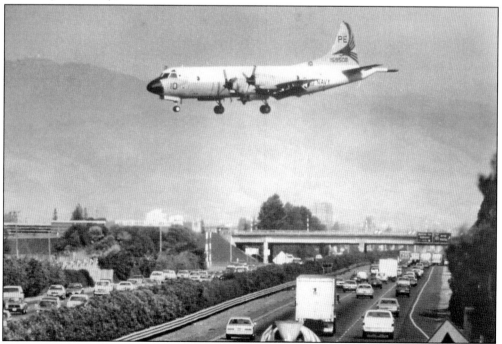

**Frequent Landings.** The P-3 Orion aircraft were a regular fixture in the skies over Sunnyvale from 1950 until the late 1980s. Returning from patrols, they would fly low and slow over Sunnyvale on their approach to Moffett Field, sometimes a dozen times per day. The distinctive grinding sound of its four turboprops and the sight of its unique stinger-like tail boom still trigger instant recognition in many area residents.

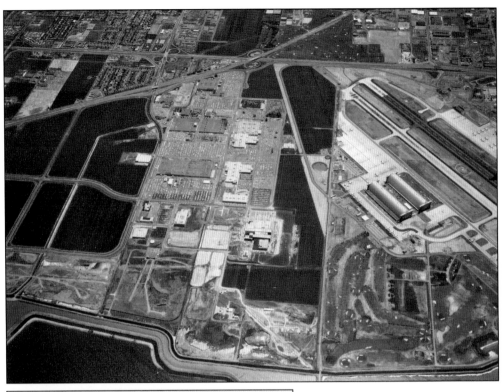

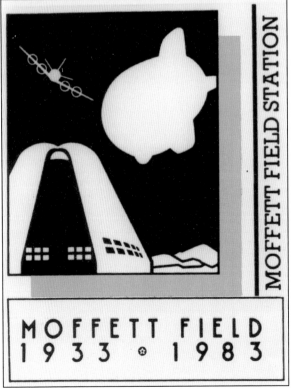

**LOCKHEED CORPORATION, MISSILES AND SPACE DIVISION, 1969.** This aerial view from the north of the Lockheed (now Lockheed Martin) building complex shows its proximity to Moffett Field, whose runways and Hangars Two and Three can be seen on the right. Lockheed came to Sunnyvale in 1956, drawn by Moffett Field and Stanford engineering graduates.

**50TH ANNIVERSARY OF MOFFETT FIELD.** Naval Air Station Sunnyvale was commissioned at 11 a.m. on April 12, 1933. Exactly 50 years later, at 11 a.m. on April 12, 1983, the station held an anniversary observance. This art-deco logo showing Hangar One, a dirigible, and a P-3 Orion was used on stationery for the celebration and as a cancellation stamp for philatelic first-day covers of the event.

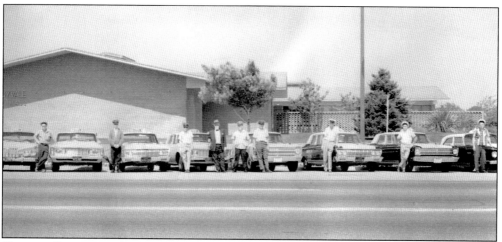

CATCH A RIDE FROM CITY HALL AROUND 1960. The Sunnyvale Yellow Cab fleet poses on Mathilda Avenue in front of the new city hall. The city government had moved to these larger quarters from the original city hall building on the corner of Murphy and McKinley Avenues in 1958. The occasion that prompted this picture is lost to history.

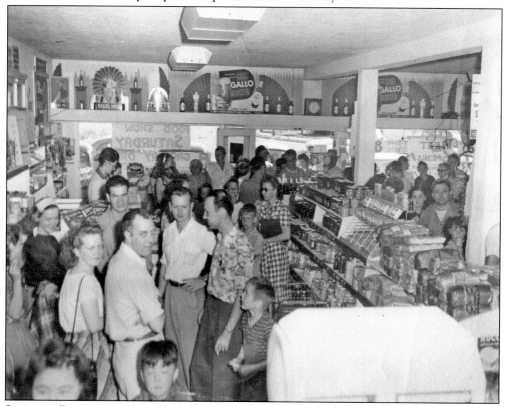

SAMPLING PARTY, 1948. Like the Green Grocery, Bo's Supermarket was a family operation, run by Steve and Maria Bo at the corner of Maude and North Sunnyvale Avenues from 1948 on. The couple purchased the store from John and Mary Duarte, who lived in a ranch house with a prune orchard next to the store. Shortly after opening, the Bo family hosted a food sampling event at the market.

BOYS' NIGHT OUT, 1987. Drive-in diners with roller-skating waitresses had their heyday in the 1950s and 1960s but were waning in popularity by 1987, when this picture was taken at Sunnyvale's Cars Drive Inn. However, cruising along El Camino Real was a popular Friday-night activity for 1980s Sunnyvale teens. (Courtesy Joe Futia.)

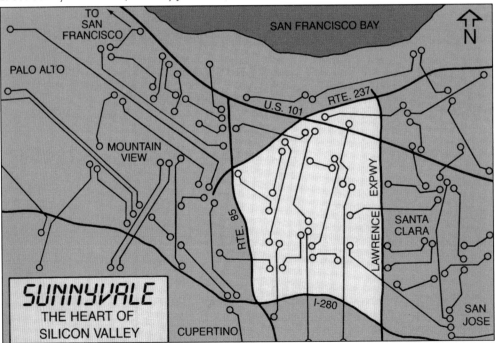

ROUTING TRAFFIC. This whimsical city-as-circuit-board postcard touts Sunnyvale as the "Heart of the Silicon Valley." Not to be outdone, San José, now using the correct Spanish accented form, branded itself as the "Capital of the Silicon Valley," and both Fremont and Los Gatos claimed to be the "Gateway to the Silicon Valley." The postcard was created by Lighthouse Productions in 1983.

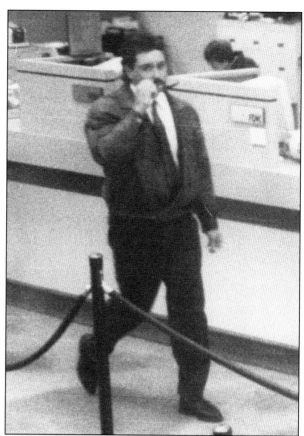

**BANK ROBBERY ON A LOST STREET.**
Although city brochures boast
of one of the lowest crime rates
in the nation, and the crime rate
per capita is indeed less than 30
percent of the national average
(using 2006 data), occasional
mayhem does occur. This
downtown Wells Fargo Bank at
300 Murphy Avenue was robbed
by this well-dressed bandit (right)
not long before the area was razed
for the Sunnyvale Town Center
mall. One of the downtown
redwood trees can be seen in the
distant background (below).

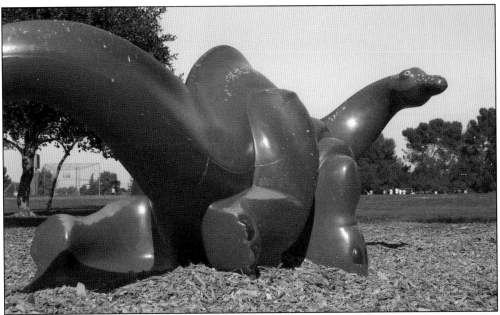

**YOU NEVER KNOW WHAT YOU MIGHT RUN INTO OUT THERE.** Sunnyvale's Parks and Recreation Commission director Richard Milkovich won national awards for his work in the mid-1960s. His joy was making both children and adults "feel like they are in another world." And so the city's 17 parks are sprinkled with replicas of the Alamo, space rockets, and Mississippi riverboats. This dinosaur is located in Raynor Park.

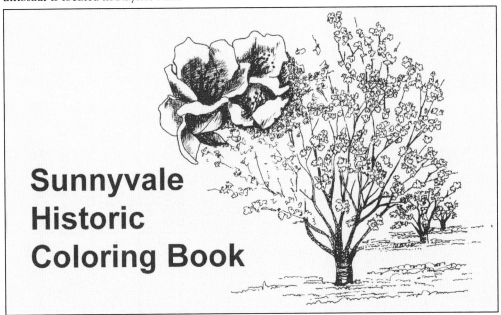

**SUNNYVALE HISTORIC COLORING BOOK.** Ann (Lopin) Zarko's brother Martin Lopin illustrated a coloring book that has been wildly successful with children visiting the Sunnyvale Heritage Park Museum. California's fourth-grade social studies curriculum emphasizes state history, and the museum is a great resource for local schools. Docents dress in period costume as students perform hands-on chores of the pioneer era.

*Five*

# PLANNED SUBURBIA

**WALTER EVERETT CROSSMAN, 1907.** This rare photograph appeared in the San Jose *Mercury Herald* newspaper and ran with the caption "Promoter of Sunnyvale." Crossman came to the Santa Clara Valley in the mid-1880s. He was a maverick developer, buying 200 acres of the original Murphy estate that had been inherited by Patrick Murphy and subdividing it into acre lots in what is now Sunnyvale's downtown. He is generally credited with founding Sunnyvale in 1897, calling it Murphy. The name "Sunnyvale" was coined (either by him or by residents whose choice he promoted) in 1901, when Murphy and another choice, Encinal (Spanish for "oak grove") were rejected by the US Postal Service. Crossman was soon joined by other developers: Harvey R. Fuller, Charles C. Spalding, George Huston, and Charles L. Stowell to name a few. Crossman himself lived in San Jose and left for Los Angeles in 1915. He never became wealthy from his Sunnyvale real estate venture. (Courtesy Mary Jo Ignoffo.)

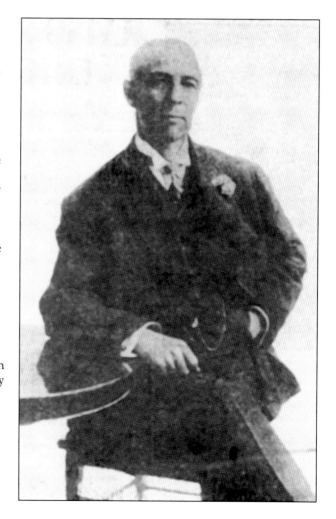

# SHIP BY WATER

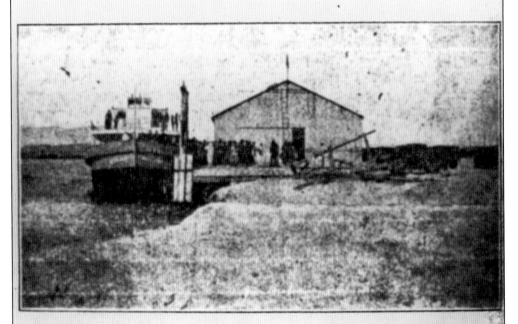

Instruct Your Shippers to Send Your Goods by

# SOUTH SHORE PORT

Pier No. 9, San Francisco          Sidewalk Delivery in the Valley

**FUTURE PORT OF SUNNYVALE.** With the construction of the Panama Canal ongoing from 1904 to 1914, worldwide shipping was on every astute businessman's mind. In establishing city boundaries for its 1912 incorporation, Walter Crossman included a strip of land to the San Francisco Bay, and in 1913, a celebration of the city's incorporation included a display of plans for the Port of Sunnyvale. Eighty Santa Clara stakeholders formed the South Shore Port Company in 1920, and construction of the proposed port began soon after. The docks were to be located at Jagel's Landing at the extreme southern tip of the bay. This shorefront property (above) was owned in the 1880s by the Jagel family, who ran a small shipping company that ferried locally produced fruit and wine to San Francisco. The property was later sold to Charles King, and it was his land that was annexed when Walter Crossman drew up the city limits in 1912. Dredgers were brought in to form deep-water docks for large shipping vessels, ferry service to San Francisco was started by 1923 (left), and there was even a small amusement park. Alas, expenses were high, the South Bay mud was formidable, and the port company landed in bankruptcy court by 1927. Although his South Shore Port venture never worked out, Crossman's establishment of town limits extending all the way to the bay would help the city win land during bitter annexation wars with other South Bay cities in the 1950s and 1960s. Today, Jagel Slough forms the northern boundary of Moffett Federal Airfield.

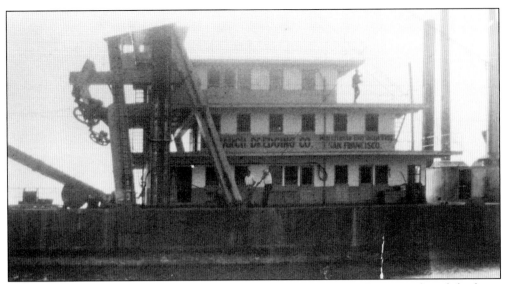

**PORT DREDGER.** Large dredging vessels, like this one from a San Francisco-based dredging company, were brought in to deepen the shipping channel to the South Shore Port. The channel was to be two miles long with a deep 300-by-600-foot basin at the docks able to handle boats up to 500 tons. (MV.)

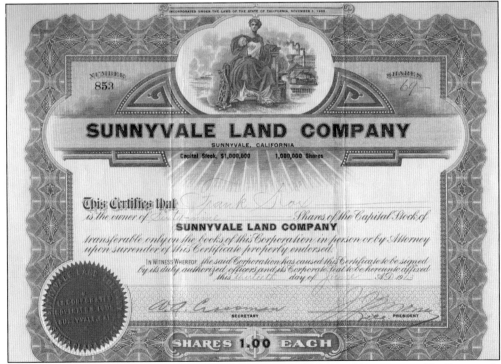

**SHARES OF SUNNYVALE.** This Sunnyvale Land Company share certificate is signed by Sunnyvale Land Company secretary Walter A. Crossman, son of developer W.E. Crossman. The company sold investment shares to the general public for $1 to finance further development of the town. It hoped to attract industry: the company's advertisement in the December 1910 *Sunset* magazine boasted of "special inducements offered to manufactories."

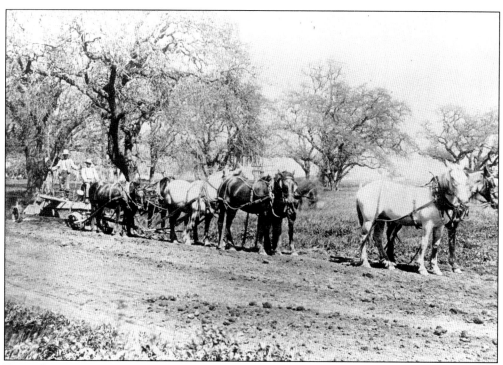

**Early Sunnyvale Horsepower around 1900.** Large horse-drawn teams were used to the draw the graders needed to create the roads in town. The early roads in Sunnyvale were simply graded dirt. Some of the larger thoroughfares, like El Camino Real, were covered in gravel as the town grew.

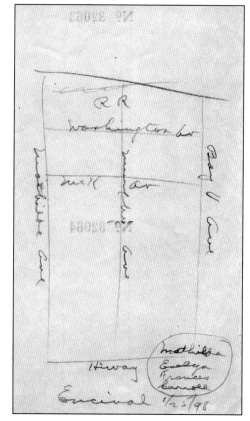

**First Map of Sunnyvale, 1898.** This road layout of the town, labeled as Encinal, sketched on the back of a receipt, shows Mathilda, Murphy, and Bay View Avenues running south from the railroad tracks, with Washington and McKinley Avenues serving as cross streets. The "Hiway" indicated is El Camino Real. Other planned street names (Evelyn, Frances, and Carroll, named for Murphy family relatives) are circled at the bottom.

**THE CITY OF DESTINY.** Walter E. Crossman advertised Sunnyvale as the "City of Destiny." Crossman cowrote this 1907 brochure with the chamber of commerce, promoting both factory and agricultural vocations: "Demand for men who are not afraid to work" was insatiable in a region where "ten acres of orchard . . . are enough to make a good living for a family." Black Cat Press, Sunnyvale's first printer, manufactured the booklet.

**SUNNYVALE QUARRY.** Gravel and dirt from this quarry helped build Sunnyvale and Moffett Field. Later, it served as a World War II artillery practice field. In 1955, Steve and Margie Barath bought the pit and built the Sunken Gardens golf course. When it opened in 1956, a nine-hole round of golf cost $1. The course was sold to the City of Sunnyvale in 1973.

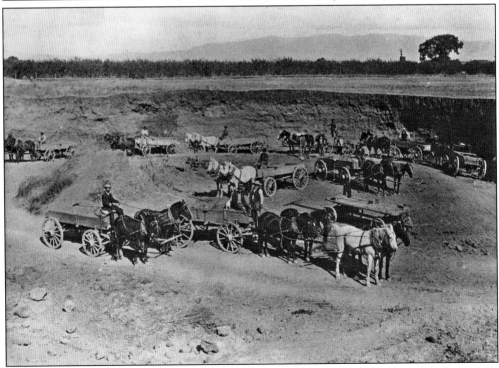

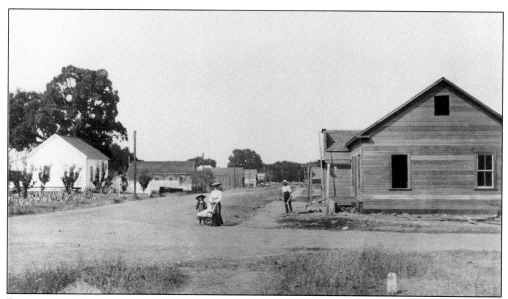

**RESIDENTIAL AREA AROUND 1900.** Houses can be seen under construction, and the roads are still just graded dirt. After the railroad came through in the early 1860s, the town gradually increased in population as the fruit industry became more developed. The town further boomed when a number of industries moved to Sunnyvale after the 1906 San Francisco earthquake.

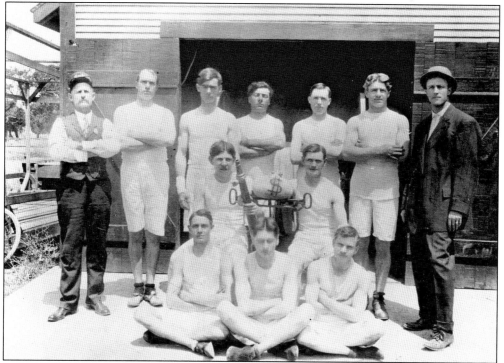

**VOLUNTEER FIRE DEPARTMENT, 1908.** This is the earliest known photograph of the Sunnyvale volunteer fire squad. Sunnyvale relied on firefighting volunteers from its earliest days until 1950, when adoption of the city charter combined the police and fire units into one paid department of public safety.

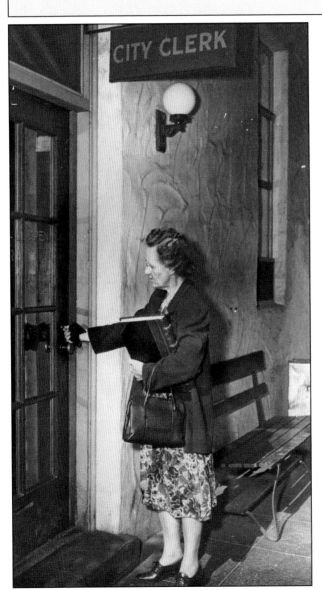

**FIRST OFFICIAL LETTERHEAD.**
Sunnyvale was incorporated
as a township on December
24, 1912, with 1,200 citizens.
The new town's stationery
lists the first trustees and city
officers, including mayor Col.
Harvey Rex Fuller; city clerk
Ida Trubschenck; treasurer
Charles Clifton Spalding, who
developed much of the Murphy
Avenue business district and
later served as a state legislator;
and Marshal W.B. McNeil.

**A 44-YEAR "TEMPORARY" JOB.** Ida
Trubschenck locks up after her
last day as city clerk in 1956. Few
individuals symbolize Sunnyvale
more than Trubschenck, who
served from 1912 until retiring
in 1956. The popular "Miss Ida"
claimed she never wanted the
job, and she never campaigned.
Friends had encouraged her
to run in the incorporation
election, which she assumed
would fail. She was continually
reelected until 1946, when the
position became appointed.

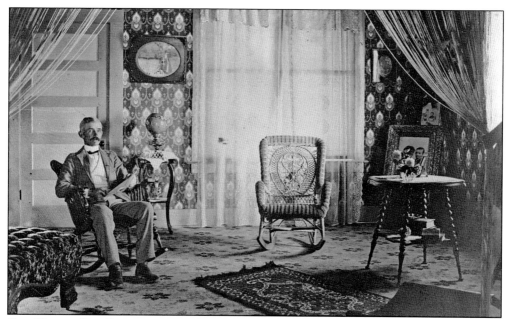

**COL. HARVEY REX FULLER, 1903.** Fuller volunteered for the Civil War at age 14, became captain of the 4th Regiment of the Iowa National Guard by 1890, and finally retired a colonel. He is shown in his newly purchased home, which became a focal point for gatherings of Sunnyvale society. Fuller became a successful real estate developer before his election as Sunnyvale's mayor by one vote in 1912. (CHC.)

**EDWINA BENNER, FIRST CALIFORNIA WOMAN MAYOR, 1936.** Benner (1885–1955), a native Sunnyvalean, became the city's first female mayor, which also made her the first female mayor of any city in California. She served two terms: 1924 and 1937–1938. Additionally, from 1920 to 1948, she was on the city council whenever she wasn't the mayor. The Edwina Benner Intermediate School was named in her honor in 1950.

**AFFORDABLE HOUSING, PRE–WORLD WAR I.** This example of working-class housing on Flora Vista Avenue and others like it were built for and owned by employees of Hendy, Wooldridge, and downtown businesses in the years before World War I. This house was added to Sunnyvale's Cultural Resources Inventory by the newly formed Heritage Preservation Commission in 1990.

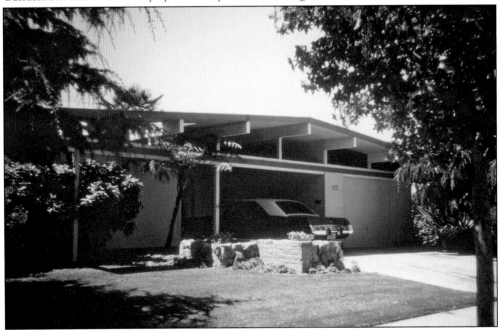

**EICHLER'S SUBURBAN BLISS.** Residential real estate developer Joseph Eichler built over 11,000 homes in California during the 1950s and 1960s. Sunnyvale is full of his innovative "California modern" homes and imitations thereof. These houses feature sharp horizontal lines and visual exposure of load-bearing beams, with sliding doors, floor-to-ceiling windows, and enclosed open-air atria. This photograph of a 1960s unit was taken on a typical sun-drenched June day in 1977.

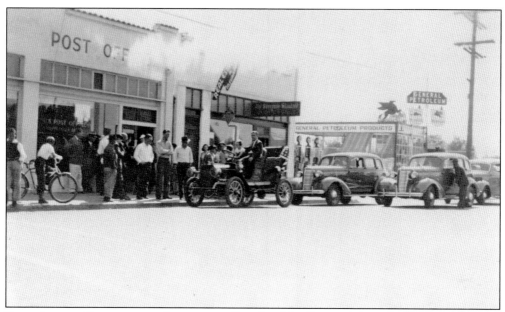

**FIRST AIRMAIL FLIGHT OUT OF SUNNYVALE.** Pres. Franklin Roosevelt launched National Airmail Week to promote airmail and aid a country still rankled by the Depression. On May 19, 1938, Sunnyvale citizens and businesses participated, and two pouches of mail, stamped at 3 p.m. in Sunnyvale, were driven from the post office to Moffett Field (top). The pouches of airmail were flown to San Francisco for their commemorative postmark, stamped at 5 p.m., and returned by Southern Pacific railcar the following day. The photograph below shows pilot and Sunnyvale businessman Henry G. Wanderer holding the mail and, from left to right, Cupertino postmaster Catherine Gasich, an unidentified postal service worker, Sunnyvale mail carriers Willard Peterson and William Golick, postal clerk Ruth Harrison, and Sunnyvale postmaster John Fahey.

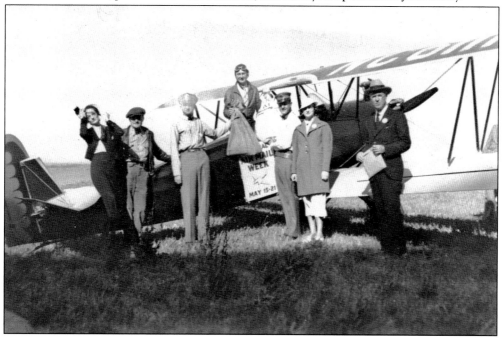

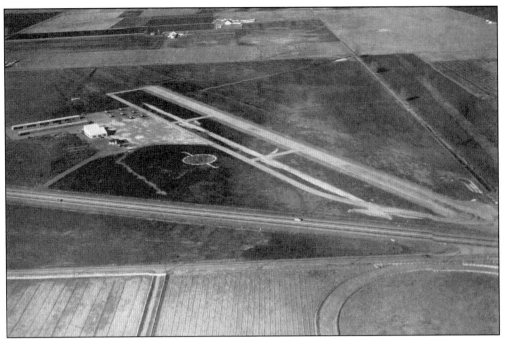

**SUNNYVALE'S AIRPORT.** Even longtime residents might be surprised to know that Sunnyvale once upon a time had its own airport. Located just north of today's US 101 freeway at Lawrence Expressway (top), the Santa Clara Valley Airport was founded in 1946 by Wonder Walnut orchardist Harold Willson, who wanted to base his own aircraft (a Globe Swift, bottom) close to home. Willson convinced nine eminent Sunnyvale citizens, including Dr. Howard Diesner (after whom Fremont High School's Diesner Field is named) to join him in purchasing 128 acres for $70,400. The airport ran for two years and 17 days. The facility was subsequently leased out, and the land was finally sold in 1956 for nearly $400,000.

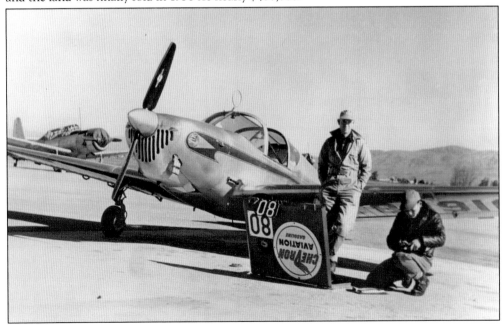

**A Changing Landscape.** The southern end of Murphy Avenue, where it joins El Camino Real, was long the official entrance to the town of Sunnyvale. Early in the town's history, as shown above around 1907, the entrance was an orchard-lined avenue. Prominent citizens donated the funds to build an electric sign over Murphy Avenue in 1920, and the following year, it was built and erected by the Joshua Hendy Iron Works (below).

Transfer Line
No. 14

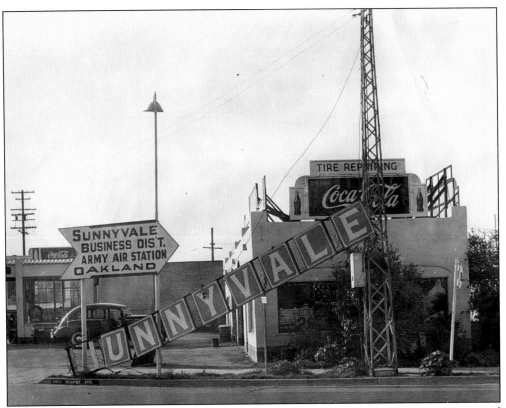

**POINTING TOWARDS BUSINESS.** The electric Sunnyvale sign eventually blew down in a storm and was dismantled in 1942. (Courtesy Katherine Brill.)

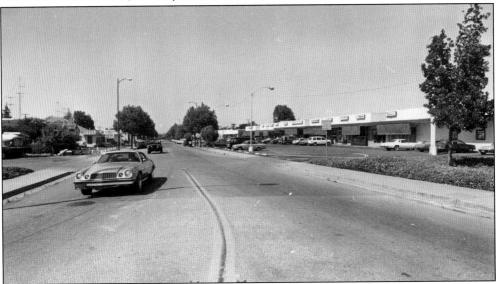

**SOUTH MURPHY AVENUE AROUND 1985.** Drivers turning north onto Murphy Avenue from El Camino Real in the 1980s encountered a wide quiet street with a small strip mall and residential housing. The Sunnyvale Town Center mall was just a few blocks up ahead. The shopping center seen on the right is still there today and remains nearly unchanged.

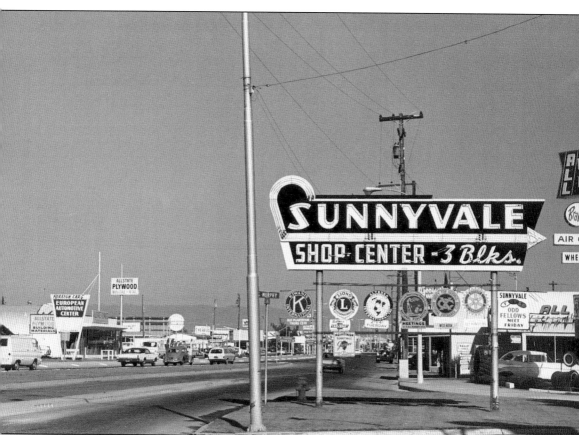

**SIGNS OF BUSINESS EVERYWHERE AROUND 1975.** The small wooden sign pointing shoppers north onto South Murphy Avenue from El Camino Real was replaced by a larger electric sign. This image shows the transformation of El Camino Real, once a country lane surrounded by orchards, to a broad avenue increasingly dominated by retail. (Courtesy Ragnar M. Petersen.)

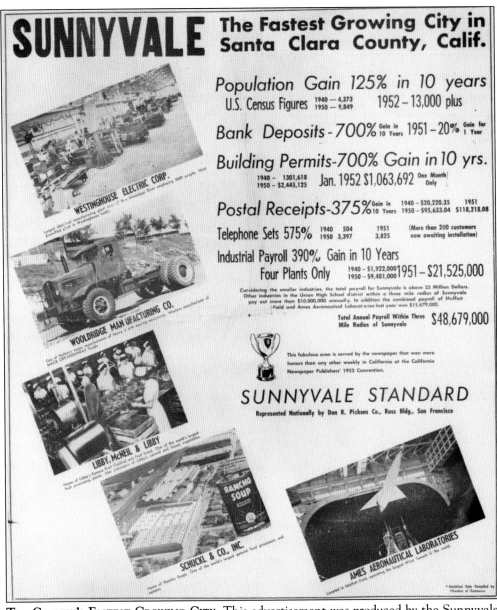

THE COUNTY'S FASTEST GROWING CITY. This advertisement was produced by the Sunnyvale Chamber of Commerce in 1952, just after it had become a charter city. Although Sunnyvale's population had more than doubled in 10 years to more than 13,000, it is likely that few imagined the phenomenal boom that was just around the corner: 53,000 residents called Sunnyvale home by 1960.

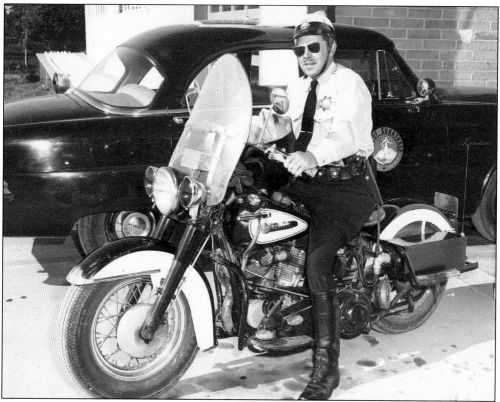

**MOUNTED POLICE, 1950S.** This Harley-Davidson was equipped for law enforcement: special lights, sirens, a two-way radio, and a unique black paint scheme. Motorcycle cops became prevalent in the 1950s, as street racing in souped-up muscle cars became all the rage for the teens of the day. Sunnyvale's Department of Public Safety still operates motorcycles today as part of its Traffic Safety Unit, consisting of four officers riding Harleys.

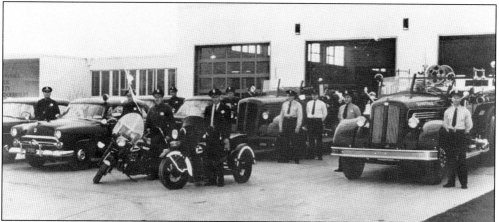

**DEPARTMENT OF PUBLIC SAFETY, ESTABLISHED 1951.** Shown here at the Mathilda Avenue station, the department was the first in California to combine medical, fire, and police services. Critics charged such split duties could result in less training, but today Sunnyvale is considered one of the safest cities in the United States. Sunnyvale was also first in the country to adopt 911 phone service in November 1972. (Courtesy Fratis Link.)

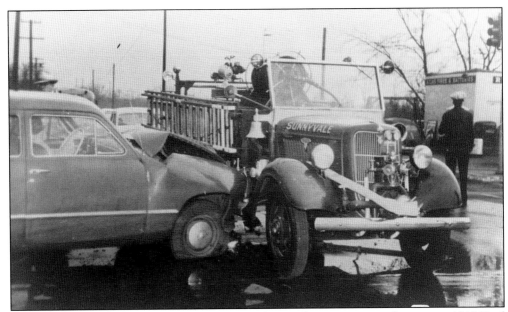

**FORD VS. FORD, 1950.** A photographer captured an unfortunate merger between a 1940 Ford automobile and a 1935 Ford/Hedberg Fire Truck based at the fire station on West Washington Avenue. The J.N. Hedberg Siren Manufacturing Company was based in San Jose at today's 280-87 freeway interchange, creating sirens with improved sound and reliability as well as entire fire trucks, according to longtime Sunnyvale resident R.L. Nailen.

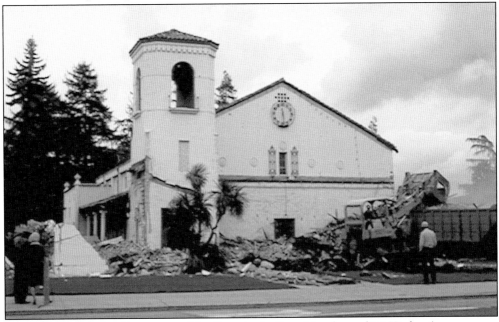

**ORIGINAL CITY HALL DESTROYED.** The first city hall, at Murphy and McKinley Avenues, was finished in 1929 as an example of Mission Revival architecture. It was demolished in 1969, but not before Manuel Vargas convinced the city council to wait 7 years to pay off the original 40-year bond. Its replacement opened in 1958 on West Olive Avenue. The downtown redwood grove can be seen behind the property.

LUNCH OVERLOOKING A CHANGING VALLEY AROUND 1958. The Schuckl Cannery office building, constructed in 1942, was an outstanding example of influential Berkeley and MIT professor William Wurster's modernist architecture. Schuckl employees had a bird's-eye view of the valley as the orchard lands that fed the cannery were systematically replaced by high-tech firms. The building was demolished several years after being denied Historical Landmark status in 1984.

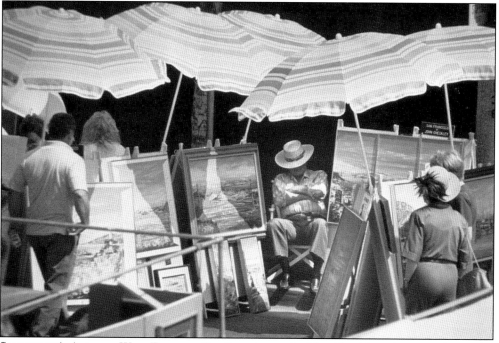

SUNNYVALE'S ART AND WINE FESTIVAL. San Francisco artist John Checkley takes a nap during the event, which has been a city tradition since 1975. The annual celebration features local artisans, beer and wine, and live entertainment. Originally held in the 200 block of Murphy Avenue, which was torn down to make way for the mall, the festival is held each June in the downtown area. (Photograph by Bob Andres.)

**CENTER OF THE COMMUNITY.** In 1962, the city council directed the Parks and Recreation Commission to prepare a proposal for a multiuse facility. In 1965, the citizens approved a bond measure, and a 13-member citizen panel determined the mix of usage for the 20 acres. Ground-breaking was in April 1971, and the $4-million complex finally opened in March 1973.

**MULTIUSE, 1981.** Luis Vasquez clears leaves and debris while a jogger runs a lap around the perimeter of the Sunnyvale Community Center's three-acre lagoon. During the late 1980s and into the early 1990s, the pool, only about one foot deep, was drained for water conservation purposes, as California suffered a severe drought from 1987 to 1992. Wet or dry, the complex remained—and remains—popular.

*Six*

# SUNNYVALE STORIES

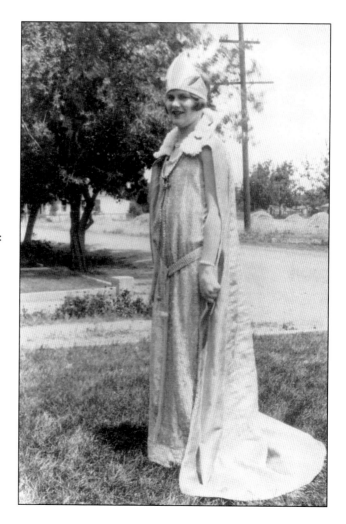

**Miss Sunnyvale.** Sunnyvale, like most other cities across the land, has its share of landmarks: the fruit cocktail water tower; the lamp post on Oak Court; the old Del Monte cannery building. These are comforting and nostalgic reminders of the place for newly arrived and established residents alike. But of course no place is made by buildings, no matter how iconic. The heart of a place lies in its people, and this chapter pays homage to the people and events that have brought the city to life. Here, Elsie Wahl Williams, Miss Sunnyvale 1926, poses for the camera at the Fiesta de las Rosas parade in San Jose.

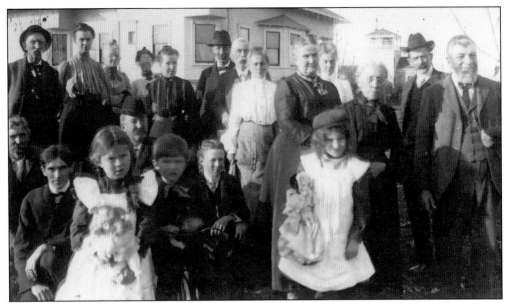

**FIRST CHRISTMAS AT THE SPALDINGS', 1904.** Charles Fuller, who also appears at lower left, photographed extended friends and family, including the Spaldings and Stowells, gathered at John Spalding's house on Sunnyvale-Saratoga Road. The society page in the Sunnyvale *Standard* reported the next day that "the dinner tables were heavily laden with the most excellent substantials," and on departing, the guests were sent off with the now-quaint "Happy New Yeay." (CHC.)

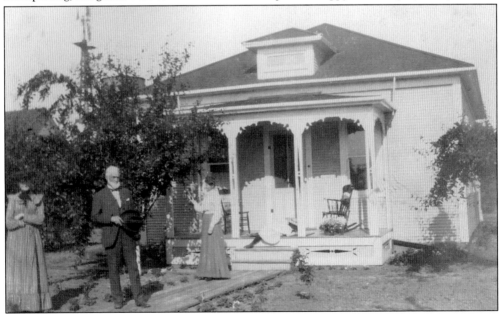

**JAMES N. AND MRS. LEAVERETT, 1906.** Charles Fuller also photographed this couple in front of their new house, the first sale in the Fuller subdivision, at the corner of Mathilda and Washington Avenues. "New buildings are started every week," enthused a chamber of commerce special advertising section in the Sunnyvale *Standard*: "To a person who has not been in the north side for two or three weeks it would be an interesting trip to visit the same and note the many changes." (CHC.)

Gramp and Nana

**MARY AND AMORY COCHRANE AROUND 1910.** This house on Charles Street was built in 1907 by Welford Cochrane for his family. Cochrane also built Fred Cornell's grocery store and general merchandise. Mary and Welford Cochrane had three children, Amory, Edwina, and Elma. Elma became Sunnyvale's first policewoman, Edwina was its first female mayor, and Amory worked as a night superintendent at Hendy Iron Works. (Courtesy Beverly Cochrane David.)

*Sunnyvale's past*

# The chicken incubator that saved a baby

By DORIS LYNN

THE YOUNG MOTHER and I sat by the living room window in her small cottage sewing for the expected baby. She was my brother's wife. Across San Francisco road, now El Camino Real, we could see the Santa Cruz mountains above vast stretches of fruit orchards.

It was the winter of 1912 and the trees were bare. February had come in so warm, however, that folks called it a "false" spring. Then it turned bitter cold. Through the night, snow had decorated the distant mountains with a white frosting. The part we could see from the window looked like a gigantic birthday cake.

"WHAT FUN it would be if the baby came today," she said. "We could celebrate with the cake Mother Nature is providing. But, I should be patient. I have almost three months to go."

Early the next morning, it was Feb. 18, she awoke with severe labor pains. We asked a neighbor to call the doctor. Her husband built a fire in the stove and then put kettles of water on to boil.

The doctor arrived in time to deliver a two-pound baby. "What chance of survival does she have?" the father asked.

"Never have I seen so small a child live," the doctor said. "But, you know the saying, 'Where there's life, there's hope'."

News travels fast in a small town. When my family moved to Sunnyvale in 1907, my brother worked for Art W. Bessey, owner of the Jubilee Incubator Co. They made chicken incubators. His building still stands at the corner of Evelyn and Sunnyvale avenues.

ANSWERING a knock at the door, my brother was greeted by a man carrying an incubator in a wheelbarrow.

"Mr. Bessey," the man said, "heard about your baby and wondered if this incubator could be used."

The doctor nodded and recommended we use it. That incubator, heated with kerosene, became home for little Phayre Atkinson, my niece, until she was nearly three months old.

She survived, became a pediatric nurse and now has several grandchildren.

(EDITOR'S NOTE — Doris Lynn, a retired nurse, has lived in Sunnyvale for 70 years. She is a director of the Sunnyvale

**JUBILEE INCUBATOR SAVES BABY, 1912.** Former Sunnyvale Historical Society director Doris (Atkinson) Lynn witnessed an extraordinary event: Jubilee owner Albert W. Bessey donated a chicken incubator to the family to save the life of her sister-in-law's premature baby. Little Phayre Atkinson spent three months in the kerosene-heated chicken brooder and survived to become a pediatric nurse and grandmother. Lynn recounted the amazing story 65 years later for the *Sunnyvale Scribe.*

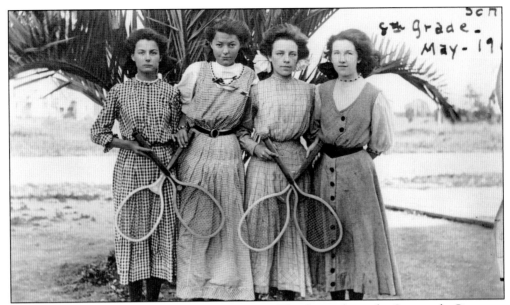

**EIGHTH-GRADE GIRLS' TENNIS TEAM, MAY 1909.** The four girls on the Sunnyvale Grammar School team made Sunnyvale their lifelong home. From left to right are Irene Setzer, who went on to marry prominent Sunnyvale banker Charles C. Spalding; Bertha Jett, remembered as "very popular and lots of fun" by Doris Atkinson; Doris, whose father was a Methodist church minister; and Vaudine Putnam, who went on to a successful career in local theater.

**SUNNYVALE COUPLE.** Born of Croatian immigrants on a nearby Cupertino ranch, a young Ann Lopin rode horses, learned to drive in a Ford Model T, and moved to Sunnyvale in 1935 as Pete Zarko's bride. Pete, a native Sunnyvalean, had his first job at the Radio Shop, worked at the Hendy Iron Works during World War II, and in between worked at Redwine's garage. Ann ran a beauty salon into the 1940s and in her long life became a beloved citizen of Sunnyvale. Her significant collection of notes and photographs is a rich source of the city's history.

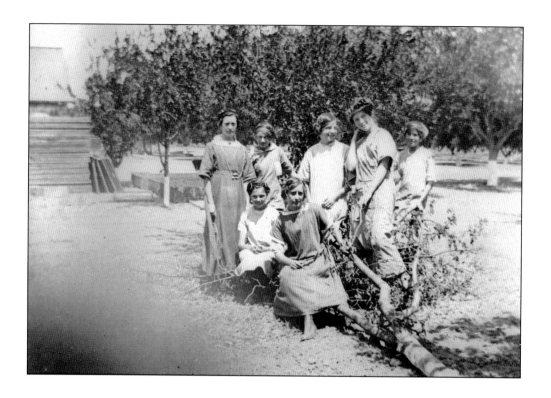

**1914 CHARLES FULLER PHOTOGRAPHS.** Fuller often photographed citizens of Sunnyvale in their everyday lives. The photograph above shows a group of young women aiding with the harvest of Willson's Wonder Walnuts. The photograph below shows the Sunnyvale School girls' basketball team. (Both CHC.)

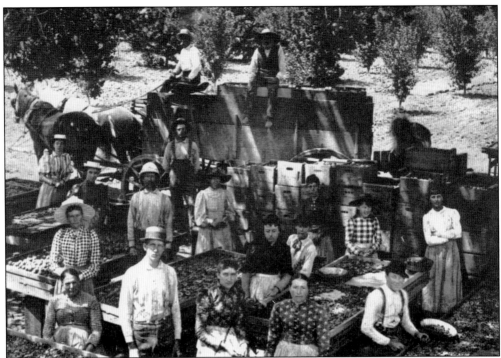

**STELLING FAMILY ON THE FARM AROUND 1900.** Henry Stelling's family owned several orchard properties in Sunnyvale and Cupertino, growing mostly cherries and apricots. Members of the Stelling family are seen here gathered for the apricot harvest around the turn of the century.

**BRIGGS-STELLING MANSION.** This storied home sits on what was the southern tip of the original Rancho Pastoria de las Borregas, on land later purchased by William Stover Hollenbeck. George Briggs married Hollenbeck's daughter Elsie in 1870 and built a large Victorian farmhouse. It was completely rebuilt after an 1890 fire (reportedly caused by the Briggs children playing with chemicals in the basement), and then reenvisioned as a Spanish stucco villa by Henry G. Stelling in 1924. In 1957, the land surrounding the house was sold to Joseph Eichler for a new subdivision.

**FIGHTING THE WAR WITH BONDS, 1945.**
Local boxer Henry Paz (center) helped raise
money for the war effort at Hendy Iron Works
during World War II. Hendy employees at all
levels, from factory-floor workers to executives,
participated in the war bond program, and
the company raised over $500,000 in war
bond purchases in six drives held between
1942 and 1945. (Courtesy Ira A. Harms.)

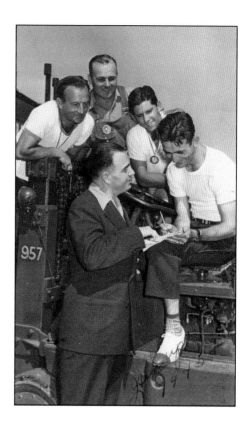

**STANLEY HARRIS, 1996.** Harris flew 77
missions in a P-51 Mustang with the famed
Tuskegee Airmen between 1943 and 1945. He
became an electrical engineer for Lockheed
in Sunnyvale, and his wife, Juanita Harris,
served as a librarian at the Public Library for
nearly 40 years. The airmen's distinguished
service was not officially recognized until
decades later, and Harris was awarded the
Congressional Gold Medal posthumously in
2007. (Photograph by George Sakkestad.)

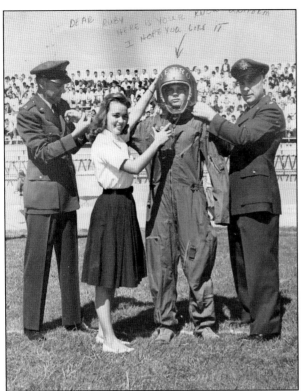

**SUNNYVALE HIGH SCHOOL AROUND 1957.** Sunnyvale High opened in 1956 to relieve overcrowding at nearby Fremont High. The Sunnyvale Jets had as their mascot Jetro, the jet plane. Here, two unidentified Air Force officers help a student don a flight suit during a pep rally. Due to budget cuts and declining enrollment, Sunnyvale High closed its doors in 1981, and the majority of the Jets returned to Fremont High.

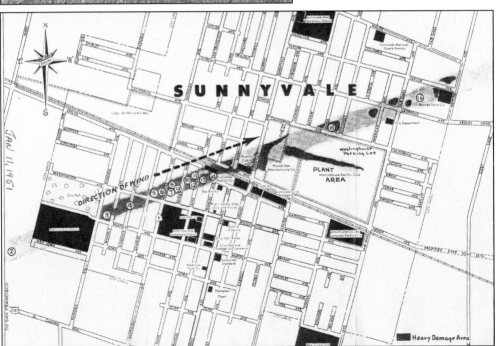

**TORNADO STRIKES SUNNYVALE.** Brazenly cutting a track of mayhem from west to east right across downtown, a twister sucked off rooftops, uprooted large trees, blew over buildings, tossed cars, and disabled power lines shortly after 8:00 a.m. on Thursday, January 11, 1951.

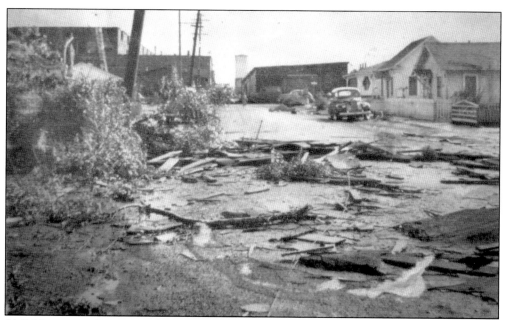

**$1.5 MILLION IN DAMAGE.** The twister, described as a "big wind," damaged over 200 buildings in the heart of downtown Sunnyvale. Even a 10-ton crane was destroyed. Tornados, especially ones with such force, are exceedingly rare on the West Coast. Nonetheless, on May 4, 1998, an even more unusual anticyclonic (rotating clockwise in the northern hemisphere) tornado of F2 intensity struck Sunnyvale and neighboring Los Altos, this time causing $4 million in property damage. Above, the Hendy water tower can be seen in the distance on this wrecked street. Below, residents try to dig out a truck crushed by a fallen house.

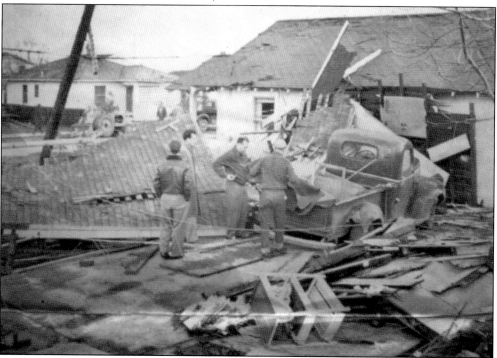

**SNOW IN SUNNYVALE.** The Mediterranean climate that allowed fruit trees to flourish in Sunnyvale's orchard heyday still makes the city one of the most livable on the continent. Severe weather is rare, and snow happens at best once every decade or so. The last measurable snowfalls occurred on January 21, 1962 (above), and February 5, 1976 (below).

**SUNNYVALE GHOST STORY.** The Sunnyvale Toys R Us, located on original Murphy ranch land and shown here during the height of the ghost craze in the early 1980s, is said to be haunted by a John or Jan Johnson who secretly pined for Martin Murphy's beloved daughter, Elizabeth Yuba. Falling merchandise, gushing bathroom faucets, and other strange phenomena are said to occur regularly. (Photograph by Bob Andres.)

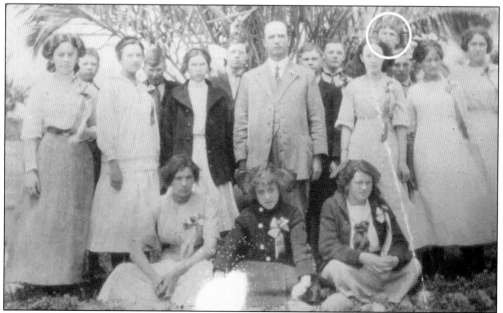

**BROKEN DREAMS.** According to legend, Johnson (circled) worked for Murphy and died a heartbroken man where the store now stands. When Elizabeth married William Taaffe, Johnson, a failed forty-niner and sometime preacher, never recovered, and he died in a gory accident apparently involving an axe to his foot or neck. Psychic Sylvia Browne has communed with the ghost at numerous séances, most famously on TV's *That's Incredible!* in 1983.

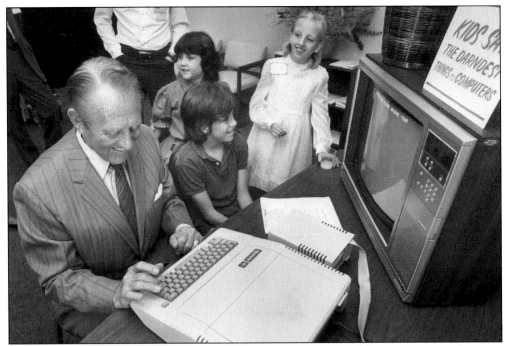

**ART LINKLETTER, 1983.** The radio and television personality joined the computer revolution in this photo op, surrounded by Sunnyvale and Palo Alto schoolchildren. Linkletter is best known for his humorous interviews with children on *Kids Say the Darndest Things*, a television mainstay for 27 years. Linkletter was also an entrepreneur and devout Christian, and in the early 1980s, he endorsed church computer systems made by Sunnyvale's Ministries Management, Inc.

**TOM HOPPIN AND "OFFICER MAC," 1988.** Longtime public safety officer Hoppin toured Sunnyvale schools with the robotic cop to teach safety and drug awareness with such programs as Stranger Danger and Safe Way to School. The $17,000 computerized device, very much in keeping with Sunnyvale as the Heart of the Silicon Valley, was funded in 1985 by Irv Kaplan, owner of four McDonald's restaurants in the city.

**INNOVATION, SMALL BUSINESS STYLE, 1986.** Sunnyvale's innovative spirit can be found in companies large and small. Inventor Bob Merrick designed the Personal Punch, which cuts notches in business cards for placement in a Rolodex. Here, Merrick Industries employee Linda Morris checks a batch. Millions of the punches have been sold over the years, and the company, which sells a host of Merrick's handy inventions, is still in business today.

**SILICON VALLEY TREASURE TROVE.** Halted Specialties Company, Inc., was located first in Mountain View, then on the corner of Evelyn Avenue and Wolfe Road in Sunnyvale, and is currently in Santa Clara. Buying up surplus electronics, often from failed companies, and selling to several generations of engineers for nearly 50 years, HSC has a worldwide reputation. Pictured is Tito Paragas looking through the "outside rack" for something interesting.

**HALTEK SPECIALTIES COMPANY**
1690 PLYMOUTH AVENUE
MT. VIEW, CALIFORNIA 94040
969-0510

*Mis-printed Bus. Forms Resulted in the Next Tenant of The building Calling Themselves "Haltek"*

SOLD TO _Steve Jabe_

INVOICE NO. _1929_

INVOICE DATE _30 aug 69_

SHIPPED TO

| QUANTITY | DESCRIPTION | PRICE | AMOUNT |
|---|---|---|---|
| /ne | Heath Kit Scope | | 62 50 |
| | tax | | 3 13 |
| | | | 65 63 |

*Rd*

*CK 50.00   J.W. Jackort #20*

**GENIUS IN THE MAKING, 1969.** Apple Inc. cofounder and industry legend Steve Jobs visited Halted on August 30, 1969, at age 14 to buy a piece of electronic test equipment. At that time Halted was located in Mountain View, and a misprinted run of sales receipt forms resulted in the next tenant of the building, itself a fondly remembered electronics surplus house, calling itself Haltek. (Courtesy Bob Ellingson.)

**WEIRD SCIENCE.** Very few surplus electronics outlets come anywhere near Halted's venerated status, but the Weird Stuff Warehouse is also well loved by local technology aficionados. Located first on Lawrence Expressway next door to a burgeoning Fry's Electronics and now in Crossman's industrial area in the extreme northern part of the city, the place is packed on many a lazy Sunday. The further one walks back, the stranger things get.

## Seven

# A City Returns to Its Roots

**SUNNYVALE'S ORIGINAL CITY HALL.** This pretty Mission-style building oversaw the transformation of the city from a population of 3,000 in 1929 to 95,000 in 1970. Colored holiday lights were hung each year by the volunteer fire department. The city offices moved to larger buildings in 1958, and the original hall was slated for destruction soon after. Manual Vargas, "Mr. Sunnyvale," tried to save the building (as he had tried to save Bay View in 1961), but it was torn down in 1969. The loss of this and other historic properties was emblematic of what local historian Mary Jo Ignoffo has termed "Sunnyvale's schizophrenia:" as progress beckoned, Sunnyvale became a city in search of itself.

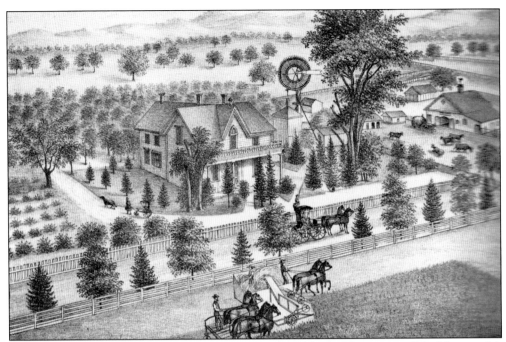

**HISTORY PRESERVED.** In the middle of a quiet residential neighborhood, one can still find Sunnyvale's oldest remaining ranch house, built by former gold-prospecting forty-niner William Wright around 1870 as he left California's gold country for Sunnyvale. This image shows how the ranch appeared in 1876. The Wright Ranch is one of nine Heritage Landmarks identified and protected by the city's Heritage Preservation Commission. (Courtesy Michael S. Malone.)

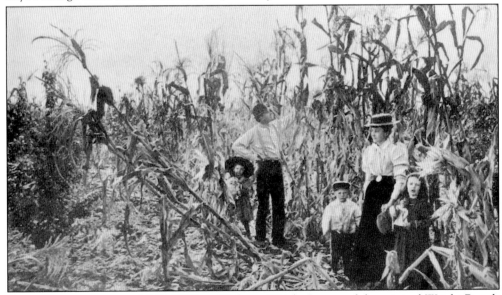

**CORN HARVEST AROUND 1900.** William Tarleton Wright Jr., son of the original Wright Ranch owner, poses with his family. William Jr. met a ghastly end in 1912 in an accident involving a jammed irrigation pump. Although true events are lost to history, he was either pulled into the machinery when his coattails snagged a moving belt or was struck by a stuck swing-arm that suddenly released. (Courtesy Michael S. Malone.)

**FREMONT HIGH SCHOOL, 1927.** The original West Side Union High started in 1923 as a temporary building on the newly purchased school lot. It took three elections to ratify the $250,000 in bonds needed to build a permanent high school, but Fremont High, designed by eminent California architect William Henry Weeks, finally opened in 1927. The first trees around the school were planted by Arthur C. Butcher.

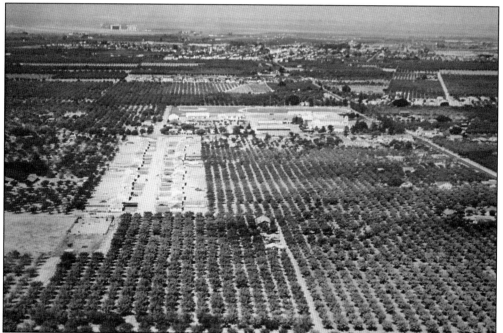

**SPREADING DEVELOPMENT, 1950.** Looking north toward Fremont High School from a point over today's Cascade Drive, a new suburban development tract bordered by today's Selo Drive and La Bella Avenue is visible in the left foreground. Moffett Field can be seen in the far background. Orchards were systematically converted to business campuses or new residential tracts to house the many workers moving to Sunnyvale. (Courtesy Fred Hill.)

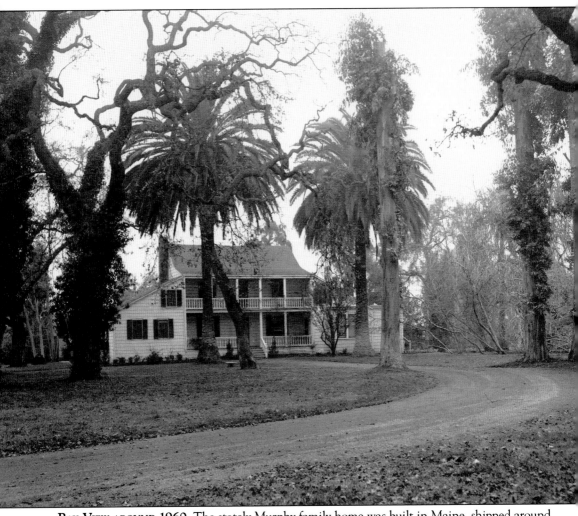

**BAY VIEW AROUND 1960.** The stately Murphy family home was built in Maine, shipped around Cape Horn, and reassembled on the Murphy property between 1849 and 1850. After over 100 years of continuous residence by the Murphys, the 20-room home at 252 North Sunnyvale Avenue was acquired by the City of Sunnyvale. Hopes were high for a community center, but the structure was riddled with termites and then suffered through a fire that caused extensive scorching and water damage. By 1954, most city council members favored demolition despite protests from concerned citizens, including Pat Malone and Manuel "Mr. Sunnyvale" Vargas. The Sunnyvale Historical Society took up the fight in 1956, and for a time, it looked as if the hard work had paid off: the house was dedicated as California Registered Historical Landmark No. 644 in 1960.

**AN INGLORIOUS END.** Citizen protest and state landmark status were not enough to save Bay View, which was deemed too expensive to repair. The bulldozers came one early Thursday morning in September 1961, and the proud but failing structure was reduced to rubble in only four hours. The destruction of this historical heart of Sunnyvale brought longtime residents to tears.

**DEMOLITION DAY.** Tempers flared as conservation advocates accused the "City of Destiny" of being the "City of Double-Cross" for not giving the historical society time to raise restoration funds. It did not help that the destruction took place a day early due to shifting crew schedules. Only a few bricks, planks, and wooden nails were salvaged from the structure. The rest was hauled off to the city dump.

119

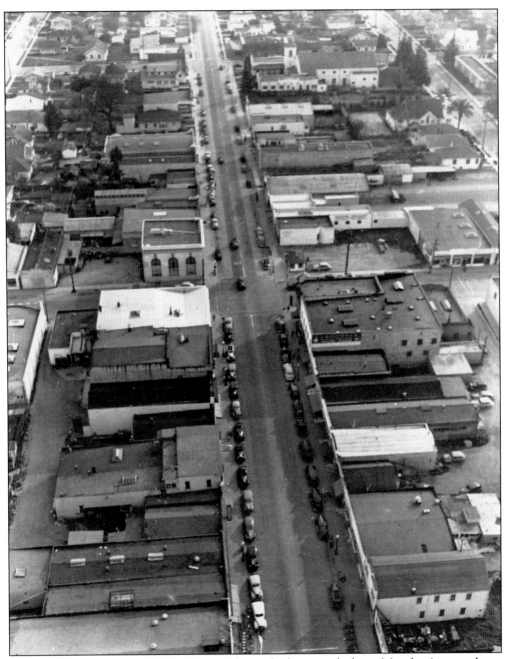

**MURPHY AVENUE BEFORE 1965.** This aerial view looking south down Murphy Avenue shows the distinctive Bank of Italy building with its high arched windows at the Washington Avenue intersection and the old city hall with the redwood grove further south at the McKinley Avenue intersection (near the top of the photograph). This block in the heart of downtown was completely destroyed in 1977 to make way for the Sunnyvale Town Center mall. The 100 block of Murphy Avenue, shown in the foreground, was spared and in the last 10 years has undergone a renaissance.

**SUNNYVALE PLAZA OPENING.** The Sunnyvale Plaza opened on April 29, 1954, as an "ultramodern regional type shopping center" (above). The plaza, located east of Mathilda Avenue (below) on the grounds of what later became the much criticized two-story Sunnyvale Town Center parking garage, served as Sunnyvale's downtown for about 20 years. While functional, it never captured the imagination of its citizens, and the city continued to build outwards in the next decades.

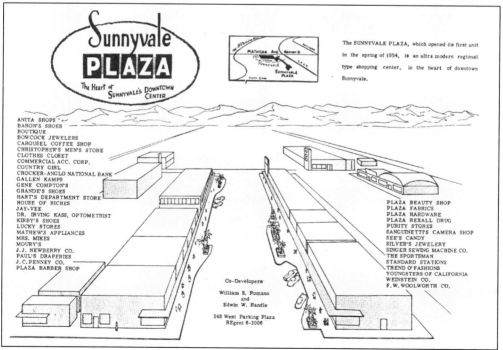

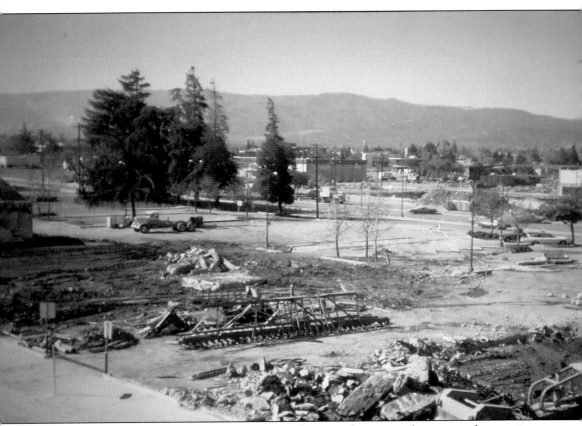

**DOWNTOWN DOWN FOR THE COUNT, 1977.** The main downtown shopping and entertainment district has struggled to find its modern identity. Most of the area's original structures were gone by the 1960s, having been replaced first by the Sunnyvale Plaza shopping center and then again in 1977 by the Sunnyvale Town Center mall (shown under construction above). Mall construction destroyed four blocks of downtown, including much of historic Murphy Avenue, but as with Sunnyvale Plaza, the Sunnyvale Town Center mall failed to bring a sense of community to the area. After years of financial struggle, the mall closed in 1995. Now a third wave of demolition and revitalization efforts are focusing on returning Sunnyvale to its historic roots. Original streets such as Taaffe and McKinley have been restored, and Murphy Avenue once again boasts a thriving lunchtime and nightlife scene. While restoration efforts in the area are ongoing, the grove of redwood trees that once surrounded the original city hall—famously saved in 1977 by Fern Ohrt—remains intact.

**DOWNTOWN BLIGHT, 1977.** The downtown area in the late 1970s looked uninviting at best. Rather than attempt to revitalize the district, the businesses shown here on Washington Avenue, including Apple Annie's in the former Bank of Italy building at far left, were demolished to make way for the new Sunnyvale Town Center mall. (Photograph by Gene Tupper.)

**SUNNYVALE TOWN CENTER NEARS COMPLETION, 1979.** Architect Ernest Hahn speaks to the *Peninsula Times Tribune* newspaper as construction is in full swing. Ironically, the walkway on which Hahn is standing and the two-level parking structure it leads to were the first to be torn down barely 25 years later. The rest of the complex soon followed. (Photograph by Gene Tupper.)

**DOWNTOWN CEDAR AND REDWOOD GROVE AROUND 1990.** Six redwood trees, mostly planted in the 1930s, grace the outdoor court of the ill-fated Town Center mall (left). This is the spot where the original city hall stood at Frances Street and McKinley Avenue. The trees were condemned for the Sunnyvale Town Center mall project but were saved by Fern Ohrt, who relentlessly campaigned during public comment periods at city council meetings. Ohrt's advocacy resulted in a design alteration of the mall to incorporate the trees, not only saving them at that time but also setting a precedent that continues to this day: the new downtown redevelopment will prominently feature the trees in its Redwood Square. Ohrt was honored in 1986 as Citizen of the Year (below) for her role in saving this important natural resource. (Below, courtesy Rod Searcey.)

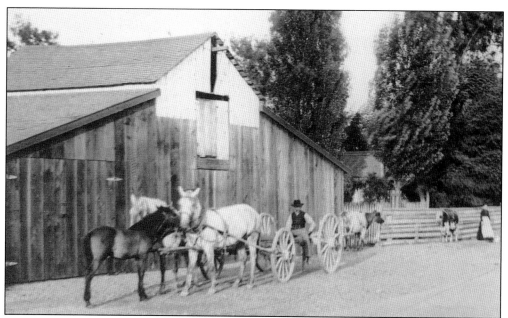

WORKING BARNS, THEN AND NOW. Although barns were a common sight in the valley from the 1850s through the 1950s, most were torn down, including the Vidovich family barn (above around 1900), as orchards and farms were replaced by houses and corporations. A few of the historic barns remain, among them the nearly identical Bianchi family barn (below). The Bianchi barn was saved only because it was moved from San Jose to Orchard Heritage Park in Sunnyvale in a byzantine legal process involving both cities and the Sunnyvale Historical Society led by Laura Babcock. Since its move, the barn has had a second life as the heart of the Heritage Park apricot growing enterprise. Workers meet there daily to check on the fruit, maintain the vintage farm tractors, or just to reminisce about the days when orchards still covered the "Valley of Heart's Delight."

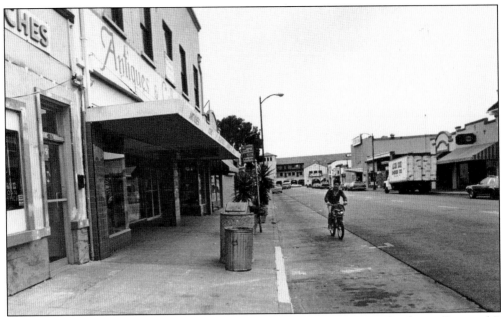

REVITALIZATION OF HISTORIC MURPHY AVENUE, **1984** VS. **2010.** Interest in redeveloping Sunnyvale's historic downtown was revived in the 1990s as the Sunnyvale Town Center, like other downtowns across America, went into economic decline, as shown in a 1984 photograph (above). Today, Murphy Avenue is enjoying a renaissance; the 100 block is filled with successful local businesses. In a newer 2010 photograph (below, taken from the same location), Amanda Marvel enjoys a quiet stroll on a lazy Sunday afternoon. The previous Saturday night had been pleasantly loud, with the street's inviting bars, vibrant bistros, and funky boutiques overflowing with patrons. The farmers market held in the area also draws a big crowd every Saturday morning. (Above, photograph by Kathryn A. Uzzardo.)

**SUNNYVALE HERITAGE PARK MUSEUM.** Constructed in 2008, this replica of the original Murphy house, complete with Canary Island palms, overlooks the Orchard Heritage Park. Although larger than its predecessor, it reflects the grandeur that impressed so many visitors to the Murphy homestead long ago. It houses the Sunnyvale Historical Society archives and museum and can be rented for weddings and community events.

**FULL CIRCLE FARM, ESTABLISHED 2007.** Assistant manager Rose Madden shows off a bushel of the farm's bounty. The 11-acre organic farm, located next to the Peterson Middle School, includes plots for growing organic vegetables, a chicken coop, and perhaps most appropriately, a fruit orchard. A growing community resource, the farm is truly bringing Sunnyvale full circle with its agricultural past.

# DISCOVER THOUSANDS OF LOCAL HISTORY BOOKS FEATURING MILLIONS OF VINTAGE IMAGES

Arcadia Publishing, the leading local history publisher in the United States, is committed to making history accessible and meaningful through publishing books that celebrate and preserve the heritage of America's people and places.

## Find more books like this at
## www.arcadiapublishing.com

Search for your hometown history, your old stomping grounds, and even your favorite sports team.

Consistent with our mission to preserve history on a local level, this book was printed in South Carolina on American-made paper and manufactured entirely in the United States. Products carrying the accredited Forest Stewardship Council (FSC) label are printed on 100 percent FSC-certified paper.

MADE IN THE